ARTIST'S BLOCK CURED!

201 ways to unleash your creativity

BY LINDA KRALL AND AMY RUNYEN

Walter Foster

Images for the following entries © Amy Runyen: 5, 8, 19, 24, 26, 28, 31, 48, 59, 62 (chimp), 65, 78, 89, 90, 92, 94, 97, 98 (collage), 102, 104 (toy photo), 111, 114, 118, 120, 138, 143, 149, 153, 160, 165, 168, 176, 177, and 183 (with Jana Rumberger). Lion image on page 62 © Nathan Rohlander.

Project Managers: Elizabeth T. Gilbert and Michelle Prather
Art Director: Shelley Baugh
Managing Editor: Rebecca J. Razo
Senior Editor: John Welches
Production Designers: Debbie Aiken and Amanda Tannen
Production Manager: Nicole Szawlowski
Production Coordinator: Lawrence Marquez
Administrative Assistant: Kate Davidson

Printed in China.

www.walterfoster.com
Walter Foster Publishing, Inc.
3 Wrigley, Suite A
Irvine, CA 92618

1 3 5 7 9 10 8 6 4 2

Introduction

There's no doubt about it—"blank canvas syndrome" can be a giant burden, indeed. But if you open your mind to new ideas, processes, and the possibility of fun, you can overcome it and learn a lot about yourself as an artist while doing so. Whether you've hit a creative roadblock or just need some encouragement, **Artist's Block Cured!** offers a multitude of ways to help you move outside your comfort zone and into the realm of heightened creativity.

How you use this book is completely up to you. Although each of the 201 entries is numbered from start to finish, you can just as easily start from the back of the book and work your way forward as you can from the beginning. Open the book at random, and there it is: inspiration. Beautiful, isn't it?

Entries are divided into six color-coded categories to make selecting an activity or piece of wisdom that much easier:

ASSIGNMENTS

This category is full of creativity-boosting challenges and step-by-step projects that outline a process, but also allow you to make the final determination about where your project goes. It's like school, but without the pressure and harsh grading.

INSPIRATION

Inspiration comes in all forms, and the entries in this category are no different. There are new concepts to ponder, thought-provoking examples of how other artists work, and suggestions for finding sources of inspiration.

MENTAL EXERCISES

These prompts send your mind in new and stimulating directions. The end product of your cerebral labor won't be on your canvas, but it will certainly be evident the next time you approach it.

EXPERIMENTS IN MEDIA

This category provides a quick and basic overview of a media or technique that may be new to you. You'll be surprised how entering unknown territory can kick start an entire series of new work! If you find a project particularly enjoyable, research the medium further. There are myriad ways to use and apply all of these examples.

GAMES

Like Mental Exercises, the games included in this category will get your brain working, but they'll also get your hand drawing in a fun and uninhibited way. Keep an eye out for collaborative games that wrangle friends and colleagues into your creative process. They'll thank you for it.

ARTIST'S SPOTLIGHT

These full-page profiles of professional artists from various genres and backgrounds offer useful advice for combating creative blocks, as well as encouragement about making a living in the art world.

You might also notice several "Did you know?" and "Do it now!" entries throughout the book. They're exactly what they sound like they should be: intriguing facts about the world of art and suggestions for spontaneous creativity-enhancing action.

We've offered 201 ways to reawaken the artist within. What you can achieve with what you learn, however, is limitless.

#1 Did You Know?

Artist Jasper Johns took cues from Austrian philosopher Ludwig Wittgenstein when approaching the canvas. Johns appreciated Wittgenstein's regard for logic and his analysis of how and why logic falters. Johns, too, sought a higher understanding of logic and used painting as a process by which to better comprehend it.

GAMES

#2 Squiggle

This is a fun drawing game to play with a partner or alone. First, draw a squiggle on a piece of blank paper; just let it flow—don't think about it (A). Then, with a different colored pen or pencil, try to make something out of your squiggle (B). Make sure to turn it around several times and view it from various angles. It can be anything: a person, animal, object, or a monster. It can even be a scene of some sort. Perhaps it becomes inspiration for a short story (C), (D), (E)… —A. R.

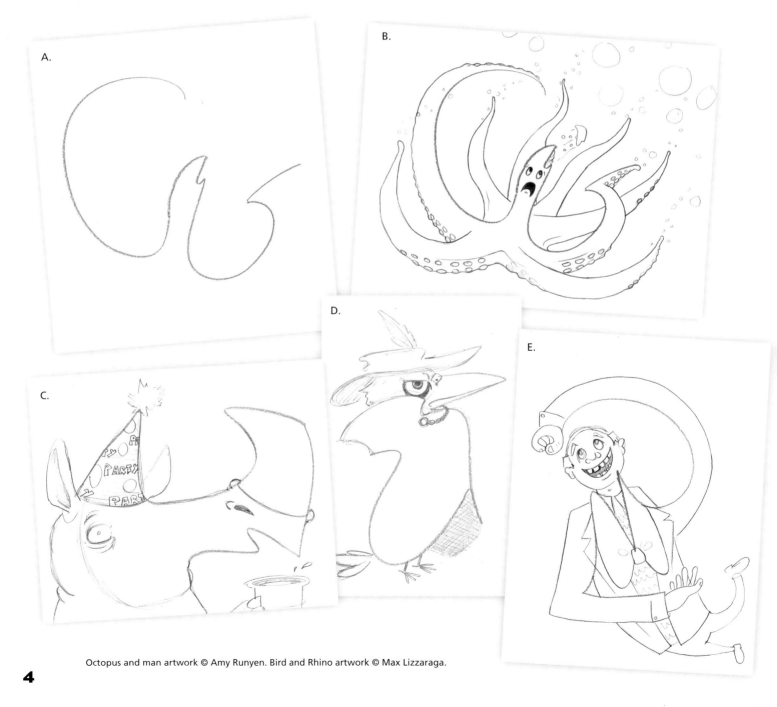

Octopus and man artwork © Amy Runyen. Bird and Rhino artwork © Max Lizzaraga.

#3 Random Shots

Artist Juliette Becker has a useful method for unblocking creativity: When you lack the inspiration to paint or draw, take your camera and start shooting anything of interest. Even random shots that may not engage you are useful because when you examine the photos later, you'll likely find something unexpected. After you finish shooting, use your computer to make a slideshow of what you shot. You can even enlarge pieces of a shot to discover unusual elements you didn't see initially. "Because I often find inspiration this way, I always carry my camera with me," says Becker. "It's amazing how many opportunities you have to find interesting subjects by keeping a camera handy. I was doing my grocery shopping one day and found this inspiration for a painting for my daughter's housewarming gift. Even grocery shopping can inspire you."—L. K.

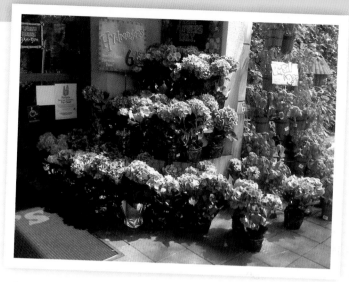

Photo © Juliette Becker

▲ A flower display outside a store caught Juliette's eye.

▶ The painting that was inspired by it.

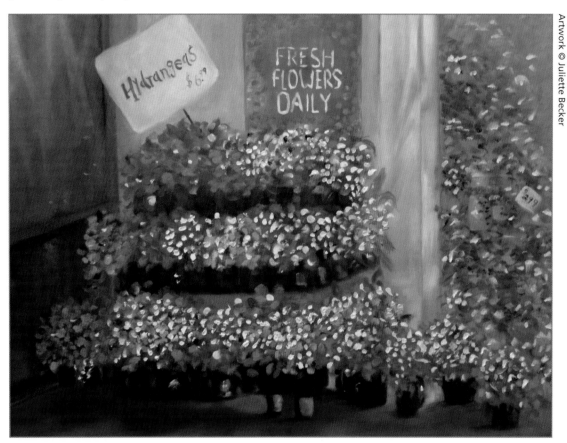

Artwork © Juliette Becker

#4 Ritualistic

Do you participate in a ritual on a daily, weekly, monthly, or yearly basis? Analyze some of your usual rituals. Why do you perform them: out of habit, a sense of duty, or because they bring meaning to your life? This could be as simple as your morning routine or as meaningful as a religious ceremony. You'll be surprised how this investigation generates subject matter for new works of art. —A. R.

Artist to investigate:
—Janine Antoni

#5 The Big Little

Create a painting of a small object from life using only large brushes on a small surface. Build up your surface from large shapes using the flat part of the brush. Use the corner and thin edge of the brush to achieve lines and details. Whatever it is that you've chosen to paint, remember that this technique is about large, bold swatches of paint and impressions of forms. The uniqueness of this process is revealed near the end of the painting when you get to the details and can't switch to a smaller brush. Detail shapes will be overgeneralized, but that's the beauty of this technique. —A. R.

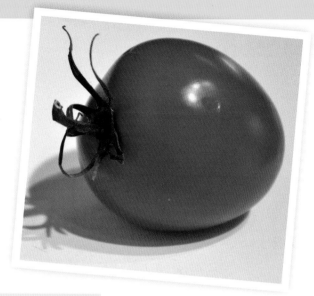

Here's what you'll need:

- Acrylic or oil paints
- Set of large brushes
- Small canvas, panel, or paper support

▲ This painting of a tomato was done on a 4" x 4" canvas board with a 12 flat brush in oil paint.

Step 1 After toning the canvas with burnt umber acrylic paint, block in the negative space with a few bold strokes. If you feel more comfortable beginning with a drawing, draw the object using the edge and corner of your brush.

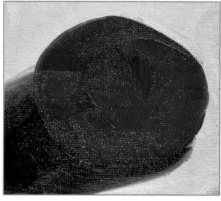

Step 2 Block in the cast shadow and basic form of the object with its dark shade.

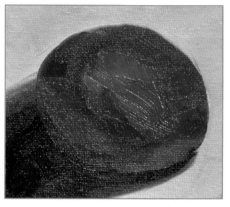

Step 3 Block in the reflected light underneath the object and the mid-tone. Let the largeness of the brush be seen. Don't overwork it; just lay color down.

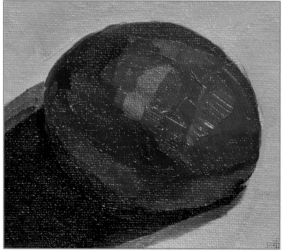

Step 4 Pop in the highlights using the corner of the brush.

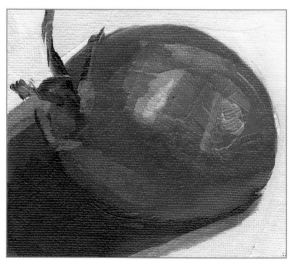

Step 5 Use the thin edge of the brush as though you're drawing with a flat laying stick to add any final details.

#6 Body Scan

When you're feeling blocked or have reached a standstill in your project, it's often a result of the tension in your body. If this is you, it's time to experience Body Scan.

Step 1 Stand or sit still and close your eyes.

Step 2 Allow yourself to become aware of the physical sensations in your body—those tense spots, as well as any emotions that arise.

Step 3 Breathe compassion into these physical and emotional sensations, giving them the space and your permission to be exactly as they are.

—L. K., inspired by Cheryl Posner

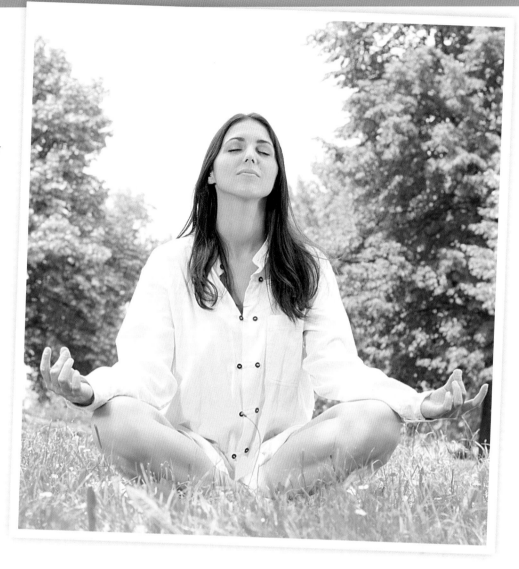

#7 Golden Light

Interior designer, artist, and jeweler Krista Everage's meditation technique is to imagine golden light flowing into her as she lies down or sits up straight in a chair and breathes. She remains aware of her five senses while connecting to the four basic physical elements of light, wind, earth, and water. Krista notices that during her workday she sometimes doesn't pay attention to her breath, which makes her sluggish. To re-center herself she begins the following meditation: "Feel the earth supporting you by visualizing lying on a warm beach, a breeze flowing over you… Imagine the ocean water enveloping you and feel the warm sun on your skin. With each in-breath visualize golden light flowing into the top of your head, and with each exhale let go of any blocks or sluggishness. Breathe through each chakra point: the crown of your head, your third eye (brow chakra), your throat, your heart, your solar plexis, your sacral and base chakras, and finally, the bottoms of your feet. The strong, focused cleansing breaths are clearing your system and relaxing your muscles deeper and deeper. Give in to the flow of your breath. As you finish with the flow of breath coming into your crown and whooshing out through your feet, visualize your whole self engulfed in a bubble of golden light and feel completely relaxed." —L. K.

#8 The Flip

Print out one of your favorite paintings from the Internet or locate an image of it in a book (A). Trace the major shapes and any smaller shapes that you like. Flip the tracing paper over so that the side you drew on is facing away from you, and then turn it upside down (B). Do you still have an interesting composition? Trace this drawing onto a piece of heavy paper, like watercolor or rag paper. Erase lines or shapes that you don't care for and add lines or shapes anywhere you please. Use the color harmony of the original painting to paint this new composition, but change the viewing orientation (C). Then try a totally different color harmony and see what it does to the composition (D). Try various media and don't hesitate to go beyond the original composition. Let the new piece of art tell you what it needs (E).

—A. R.

Here's what you'll need:
- Art print
- Tracing paper
- Watercolor or rag paper
- Pencils
- Various wet and dry media

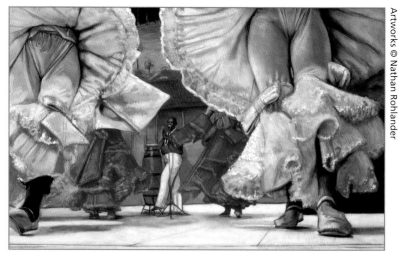

Artworks © Nathan Rohlander

A. *Front Row,* oil on canvas, 40" x 60", 2004

B.

C.

D.

E. Collage

F. Charcoal and gesso

#9 Back to Nature

Getting outside and connecting with nature is a great way to tap into your creativity and imagination. Go to a park, a wooded area, or a place to rest near water. Sit quietly and learn to look, listen, and feel your surroundings. Use a pencil, Conté crayon, or even watercolor to create an interpretation of the birdsong, the rustling of leaves, the babbling brook, the chatter of the squirrels, or the rays of sunshine. Let your imagination run wild. —L. K.

▶ Something's in the air…

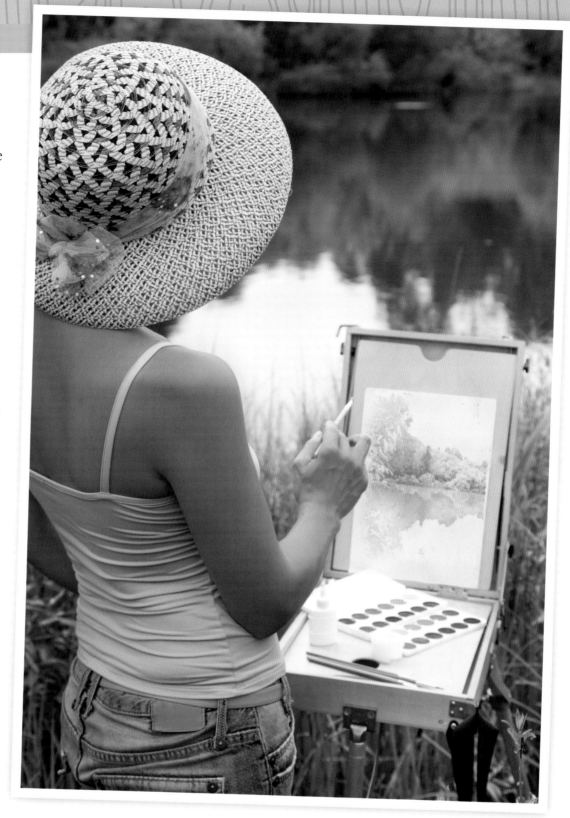

#10 What's in Store?

Think of three different types of stores—the 99 Cents Only Store, Nordstrom, and Whole Foods, for example. What does the idea of each of the stores you chose look like? If you could boil the stores down into solely shapes and colors, what would they look like? Create a triptych out of paint and/or collage on paper, canvas, or panel. —A. R.

#11 Colorful Mind

Find small swatches of colored paper, like paint chips or scraps of construction paper. (This will work best if the colors aren't pure hues, such as red or green, but less intense colors, such as magenta or olive green.) Paste the swatches into your sketchbook and write a very brief description about what each color makes you think of. Does it remind you of any particular time in your life? What name would you give that color beyond its hue? What smell would it have? How would it taste? Could it have a texture or viscosity? Explore all conceptual options that the color may have and write the first ideas that come to mind. —A. R.

- Name: New Growth Green
- Reminds me of the color of the wall paper in my childhood bedroom. I also keep thinking of birds when I see this color.
- Smell: Lemons and garlic
- Taste: Pistachio ice cream
- Texture: Creamy

- Name: Jazz Plumb
- Reminds me of Savannah, GA and for some reason I think of plumbs in a dark night club.
- Smell: Mulling spices
- Taste: Sweet and rich. Fruity with a pinch of cinnamon.
- Texture: Liquid, juicy

#12 Five Senses Studio

Award-winning interior designer and jeweler Krista Everage is immensely influenced by her immediate environment. For two years she searched to find the perfect coastal California bungalow with good light, views of trees, and an ocean breeze. She since has developed and cultivated an environment that utilizes the four physical elements of earth, water, light, and air. A beautiful garden grows around the perimeter of her home and can be enjoyed visually from the interior space, while a combination of flowers, plants, and organic candles add fragrance to her home, heightening the sense of smell. Krista believes all five senses must be addressed when designing an interior—color, texture, smell, bowls of nuts and fruit for taste, and delightful music. Assess your living space and jot down the ways it engages your senses. Then brainstorm inventive ways to enhance your sensory experience and jog those senses that may not be receiving enough stimulation in your home. —L. K.

Photo © Michael Garland

A studio designed for creativity

#13 Inspiration Quarry

Look through art magazines, arts sections in newspapers, and art web sites to find pieces of artwork you find compelling. Paste them in your sketchbook, or a sketchbook especially designated for this exercise. Perhaps you chose a piece of artwork for how the artist used color; maybe another exhibits a unique use of pattern. Each piece needn't be a complete package of aesthetic arrest. As long as there are elements from which you'll draw inspiration in the future, it's worth saving. So what if you find an advertisement for a wedding cake visually interesting…go ahead—throw it in! You never know when or how it may come in handy. Eventually you'll build up a collection of work to inspire you during those dreaded times when your brain is stale. —A. R.

Artworks shown by Nathan Rohlander and Jana Rumberger

#14 The Web

Think about a spider's web, and then write down the first thing that comes to mind. Did you first think of the beauty of a dewy web illuminated by the morning light at dawn? Or did you project the fear of the helpless insect caught in the web about to be slowly consumed by the nefarious spider? Did you ponder the amazing geometry of the web itself or the tremendous effort that the spider put forth to weave it? Consider that how you perceive the web is indicative of your own emotional landscape and past experiences. Knowing yourself and how your mind reacts to various scenarios like this one can help you assess the way you should visually approach any concept. —A. R.

#15 Meditative Mandala

Using a template or a circular object such as a margarine container lid, draw a circle on a blank piece of paper. Start anywhere inside the circle and doodle lines, swirls, patterns, checkerboards, or whatever takes shape as you move your pen across the paper. Want to add some hearts or dolphins? Feeling for flowers and stars? Anything goes. The only objective is to keep your doodles inside the circle. Make your design in black and white, or add as many colors as you like. Fine-tip markers are great for drawing meditative mandalas. Pack up your pens and a small pad of paper, and doodle your mandala anywhere you find a place to put down your sketch pad, whether it's a coffee shop, bookstore, or the park. Listen to music as you doodle and let your creativity flow! You can't make a mistake. —L. K.

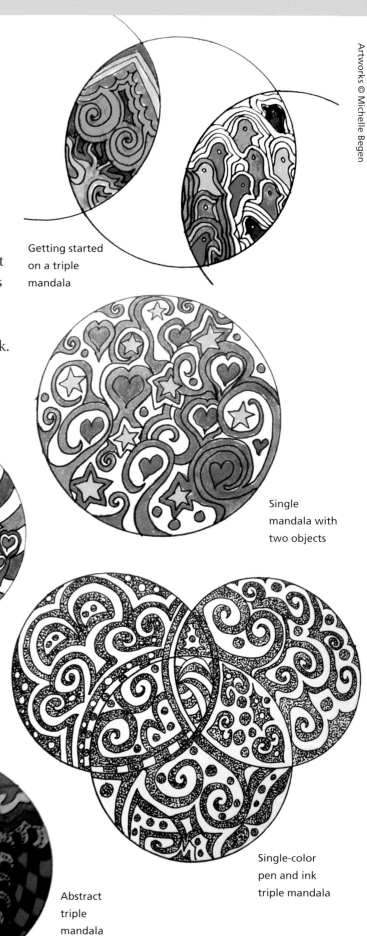

Artworks © Michelle Begen

Getting started on a triple mandala

Single mandala with two objects

A nature-inspired triple mandala

Abstract triple mandala

Single-color pen and ink triple mandala

#16 Magic Weekend

You and a partner are tasked to spend two days together with only five dollars to spend. You decide who your partner is: a friend, coworker, significant other, parent, child, etc. Next decide the location and what you'll do. Perhaps you grab some free coffee and doughnuts at a church or synagogue. Or maybe you go for a long bike ride at the beach or attend a free music festival in the park. Are you enjoying stargazing with a cheap bottle of wine? Did you raise money for a cause by hosting a bake sale? Draw or paint your Magic Weekend, taking into account the creative choices you imagine. Imbue the illustrations with the sounds, images, vivid colors, tastes, textures, and movement of all the fictional things that transpired. —L. K.

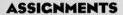

#17 A Touch of Gray

When you feel an urge to paint, begin in black and white before proceeding with color. Gray tones allow you to see the lights, shadows, and values much more clearly. Another way to make sure your contrast is correct is to take a black-and-white photo of your work-in-progress; you'll begin to see where you need to add contrast. A black-and-white snapshot also helps clarify the values of each tone. Before completing a painting, artist Juliette Becker always takes a black-and-white photo to assess the subtleties and intensities of the values and tones. Try this technique to gain a different perspective and work through your block. —L. K.

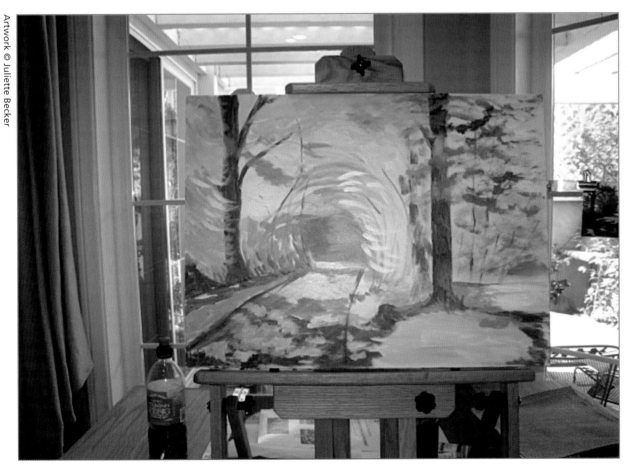

Artwork © Juliette Becker

A painting started in black and white and finished in color

#18 Domenic Cretara

Biography: Domenic Cretara, Professor of Art at California State University, Long Beach, in Long Beach, California, works primarily in drawing and painting. He earned his Bachelor and Master of Fine Arts degrees from Boston University School of Fine Arts and was a Fulbright Scholar to Italy. He has had many solo exhibitions, including a solo show at the Frye Art Museum in Seattle, Washington; a retrospective at the Las Vegas Art Museum; and group shows in venues on both coasts of the United States and in Europe. His works are in the collections of such major institutions as the Metropolitan Museum of Art and the Art Institute of Boston.

Q: Where do you find inspiration for your artwork?

A: My inspiration derives primarily from responses to my own life experience, from an ongoing dialog with art history and from reading widely in literature.

Q: What advice would you give to a blocked artist?

A: Draw as much as you can. It doesn't matter what you draw or from what resources you work. It also doesn't matter what materials you use, although I would recommend alternating between materials that you are familiar with, and those which are new to you. Don't think of making finished drawings; just draw. If done persistently this practice will inevitably lead to new visual ideas for your work.

Q: How do you balance your creative impulses with making work that consumers will buy?

A: I don't. I've never knowingly let the marketplace influence what I paint or how I paint it. This is not the result of some "Public-be-Damned" arrogance on my part. I just wouldn't know how to let public taste (if such a thing even exists) influence me even if I wanted it to. I simply believe that as a human being I am not so different from everyone else, that someone out there will not be able to be excited about what I find exciting—will not be able to see beauty where I discover it.

Q: Can you remember a class or an assignment from art school that challenged your creativity and possibly helped to redefine your aesthetic or thinking? If so, what was it?

A: When I began as a freshman at Boston University's art school I saw in terms of carefully observed separate parts which I then cobbled together as best I could. Amazingly, I thought I already knew everything about drawing! John Wilson, my beginning drawing teacher, patiently worked with me to dismantle my preconceived ideas about drawing. He taught me how to think from the whole to the parts. He connected light and shadow with the concept of planes in space. It wasn't any specific assignment that reformed my thinking. It was Professor Wilson's constant, tireless corrections of my work and his logical exposition of the aesthetics of form in space that set me on the right path. —A. R.

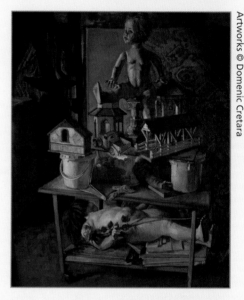

Still Life With Dolls, oil on canvas, 72" x 60", 2011

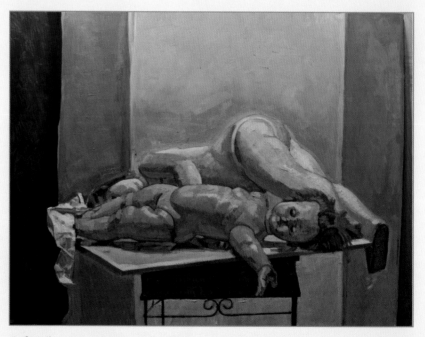

Raft, oil on canvas, 48" x 60", 2011

#19 Puncture Drawings

Pouncing was a technique used to transfer drawings or "cartoons" to freshly plastered walls for fresco. Artists pricked little holes along the lines of the drawing before holding it up to the wall and "pouncing" powdered charcoal or chalk over it to transfer the image. Little dots of charcoal aligned to guide the painting. Though the punctured drawing wasn't considered art, the texture the puncturing produces is quite beautiful. You can use this technique to create a quiet drawing made only of holes or as a textural element on a drawing or painting on paper. —A. R.

Here's what you'll need:
- Heavy paper of any color
- Pencil
- Hammer
- Nail
- Board to protect working surface

Step 1 Create a simple design in your sketchbook that works well as a line drawing and/or high-contrast value sketch.

Step 2 Draw your design in pencil on the backside of the paper. Make sure that it's backward, so when you turn the paper over after puncturing, the design is reversed. Draw dots where you'll be making puncture marks. Consider the intervals between the dots. Do you want them very close together to create a darker line or farther apart for a lighter line? Perhaps some of the lines should be tapered off at the ends by making successively greater distances between dots.

Note: *When your drawing with dots is completed before puncturing, you can clamp various pieces of paper together to make more than one drawing at a time.*

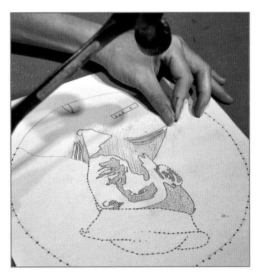

Step 3 Place a protective piece of plywood or thick cardboard underneath your drawing to protect the surface you're working on. Begin hammering in the nail along the path of the dots. Consider varying the size of the nail holes to give more visual interest. For this example, I shaded in some of the shapes that were to be a darker value to avoid confusion, and then added random small holes to the area.

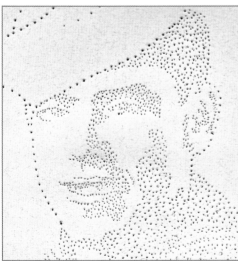

Step 4 The final product is a surface with a lovely texture.

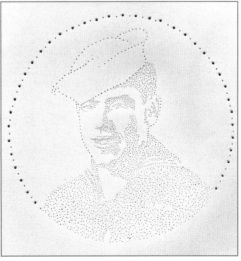

Step 5 After you've completed the puncturing, turn over the image and assess whether or not you need to add more holes.

James E. Runyen 1944, 2011

15

#20 **Narratives**

Using narratives as inspiration to make artwork is an age-old practice. In ancient Egypt, artists told the story of creation in images painted onto tomb walls. Mythical and Biblical stories are the basis for most of the art made during the Renaissance and beyond. Images have the power to communicate ideas to a global audience beyond the limitations of the spoken and written word.

What kinds of narratives do you gravitate toward? To create your own story on which to base work doesn't mean you need the literary mind of Mark Twain. Simply having a basic plot outline and a few characters is enough. If writing your own story isn't for you, there's nothing stopping you from using an existing narrative. Use a favorite poem, nursery rhyme, short story, or epic novel. Try creating one piece of artwork as though it were a book cover for your story. Beyond that, ask yourself how this one story can provide material for several pieces of art that have a "dialogue" with one another. If ever you feel blocked for ideas, just remember that millions of stories have been written over time. Just open a book and draw!

Artist Siobhan McClure creates narrative oil paintings using children as her subject matter. Her personal story is about children in exile from a failed urban society, whose rules and regulations no longer serve their best interests. They must band together and make it to the Arcadian land of "The Beyond" in order to survive. Laced with symbolism, these paintings give the viewer information about the intended narrative. From the heightened linear perspective in the flawed underworld to every gesture and costume of the children, the viewer can follow the

course of events. Each piece stands on its own as an individual story and also contributes to the larger narrative like a page in a beautiful book. —A. R.

Artists to investigate:
—The Pre-Raphaelites
—Any Renaissance Artist
—Trenton Doyle Hancock
—Laylah Ali

#21 Parts of a Whole

While vacationing in Hawaii, artist Juliette Becker found inspiration in a beautiful hibiscus, photographed it, and created this original painting (A). Try taking one of your paintings that you really like and painting it in a different way. Juliette divided her original into thirds and painted those segments on separate canvases to create a series of entirely new creations (B, C). —L. K.

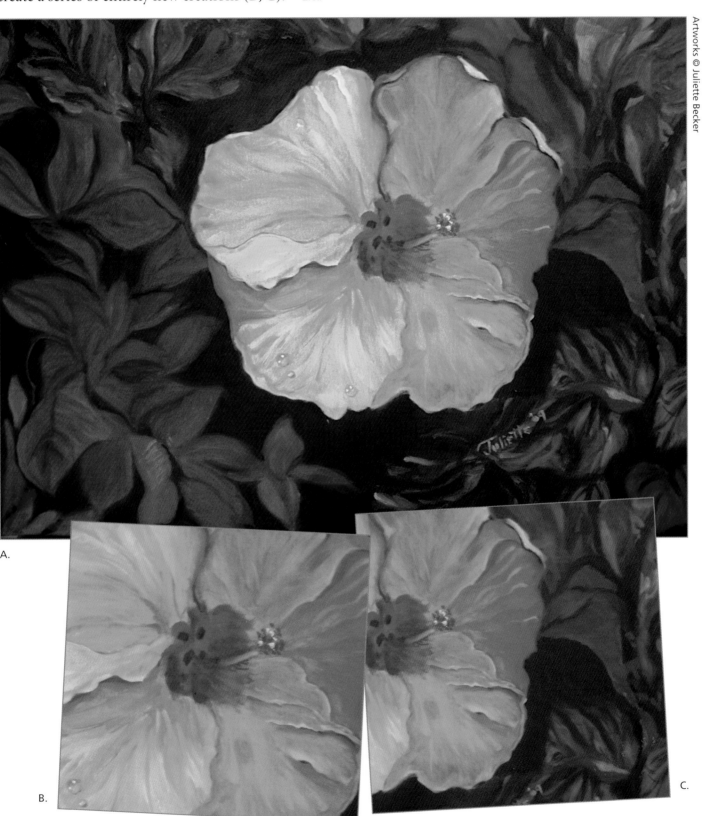

A.

B.

C.

Artworks © Juliette Becker

#22 Progressive Painting Party

Invite a group of fellow artists to your home or a recreational area and ask them to bring a predetermined-size canvas. Divide the amount of time you want to spend together by the number of artists. Begin creating on your own canvas, and when your allotted time is up, move to someone else's canvas and build off of his or her creation. Continue until you have added something to everyone's canvas. The exciting products that result from inspiration, interpretation, and collaboration will surprise everyone. —L. K.

#23 Snakes in the Grass

Step 1 For this exercise inspired by strategy, insight, and innovation expert Sandie Glass, cut a string about six to eight inches long.

Step 2 Dip the string into some paint. It can be poster paint or anything water-based you have available. Imagine the string is a snake and let it move about and squiggle around on the paper. Pretend it's curling up to sun itself or that it's making its way through the grass to find dinner.

Step 3 Cut another six-inch or longer string and use a different color paint to add dimension to your original image. Repeat as many times as you like.

Step 4 Try it again using another object, such as a twig or a feather. —L. K.

Here's what you'll need:
- Ball of string
- A variety of water-based paints
- Other found objects for texture

#24 Rorschach

Based off the Rorschach Inkblot psychology tests, this fun game is an excellent creativity booster to play alone or with two people of any age. —A. R.

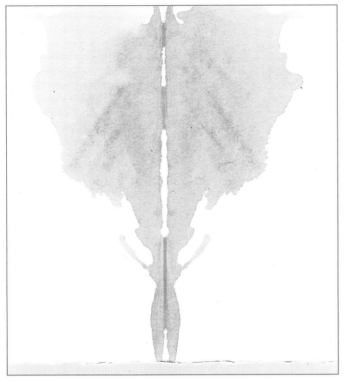

Step 2

Step 3

Step 1 First, create an inkblot by dripping watered-down ink onto one half of a piece of paper.

Step 2 Fold the paper in half, pressing both sides together to make a symmetrical blot of ink on each side.

Step 3 When the ink is dry, draw over the inkblot to fully realize the image that you perceive it to be. Have fun doodling as you practice a little armchair psychoanalysis.

#25 Toward Abstraction

Artists who work representationally often have difficulty thinking abstractly. But working from an abstract perspective can help refine the formal aspects of designs while adding layers of depth to concepts. A system of asking questions ultimately boils down the figurative quality of objects.

Take any old noun—*tree,* for example. What are some adjectives that describe the idea or character of *tree?* Tall, elegant, craggy, sturdy, flexible, etc. Now, what do those words look like? How could you visually describe flexible, yet sturdy? Elegant, yet craggy? Now we're getting abstract, but the point of departure was something very recognizable.

The same can be done when starting with an adjective. Let's take the word *rich.* When you think of *rich* what comes to mind besides the typical dollar sign and gold coins? What types of things do rich people have? Make a list: expensive cars, large mansions, servants, well kept gardens—perhaps the opulent drapery of a Baroque Empress's bedroom. Now think of the shapes, colors, patterns, and lines found in opulent drapery. Reducing the original idea of rich to its formal qualities is one way to discover what it looks like abstractly to you. —A. R.

#26 Hand-Pulled Monotype

A monotype is a one-of-a-kind print. Pressing a painted, nonporous plate to paper causes the ink or paint to sit on the paper in a unique way unachievable when applying the medium directly. This example uses the subtractive process of monotype printing: removing ink or paint from a field. Use many colors or only one. There's no wrong way to create a monotype, which leaves the door to creative possibilities wide open. You must be patient, however! It can take a few tries to get the hang of it. Start with some simple test prints on cheap paper. —A. R.

Here's what you'll need:
- Printing ink, oil paint, or acrylic paint
- Several paintbrushes
- Plexiglass, glass, or metal plate cut to the desired size
- Rag paper
- Cotton swabs
- Cheesecloth
- Paper towels
- Brayer and rubber gloves (optional)

Step 1 First, squirt a generous dollop of paint or ink directly onto the plate and use a brayer to even it out. Make sure that you use enough paint, or the print will be too light. If using acrylic paint, use retarder to slow the drying process. An 11"x14"-plexiglass plate and water based printing ink are used in this example.

Step 2 After the plate has been "inked," wipe off any dirty edges. Next, use a paintbrush or cotton swab to draw your subject in reverse so it prints the correct way. Then put a piece of white paper behind your plate so that you can easily see the drawing emerge.

Step 3 In this step, use cheesecloth and paper towels to pull out the midtones of your subject. Cheesecloth gives a hazy texture to the shapes removed and paper towel removes paint cleanly. Use a paper towel or cotton swabs to pull out final details and highlights. Now add paint back into areas from which you feel you pulled out too much and rework them. At this point, you can use the additive process and draw with paint into any clean areas you wish.

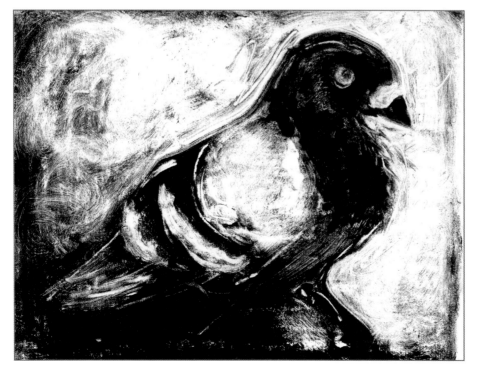

Step 4 Complete your print by laying a lightly moistened sheet of paper on top of the plate. Gently apply a generous amount of pressure with your hands and/or brayer starting from the center outward. Then slowly peel the paper from the plate and set it aside to dry.

#27 Fabric Collage

To unblock your creativity, Pamela Marsden, a set decorator and the Program Director for the Chuck Jones Center for Creativity, suggests visiting a fabric store to collect swatches of the textures, colors, and patterns that excite you. Take them back to your workspace and consider how they might create a picture. Can you spot tree bark in a texture? Is there sky in a color or weave? Explore the possibilities and let the fabric guide you to create a new world. —L. K.

#28 Color Harmony Collage

Create an abstract collage using various color swatches based on a particular color harmony and compositional structure. Begin by gathering colorfast art papers, paint chips, and large swatches of color from magazines. Any type of image (a patch of sky, an animal, or a person) will suffice. As you build a stockpile of color swatches, collect them in a box for future use. This process is great when trying to figure out a color harmony for a piece of art you're working on. —A. R.

Words to Create By

The following is a list of color harmonies. Note that all hues may use their tints and shades.

Monochromatic One color with varying values. (Example: red, pink, and maroon)

Analogous Three colors that are adjacent to one another on the color wheel, plus the tints and shades of each hue. (Example: blue-green, green, and yellow-green)

Complementary Two colors that are directly across from each other on the color wheel. (Example: blue and orange)

Triadic Three colors that are evenly spaced around the color wheel. (Example: red, yellow, and blue)

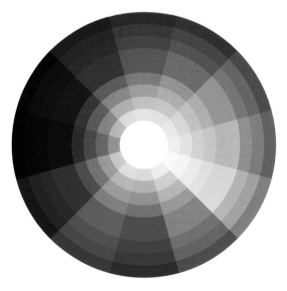

This color wheel illustrates tints and shades of the twelve basic hues, with the pure hue of each shown larger in the center ring.

Analogous color harmony (blue-violet, violet, red-violet) with an L-shaped composition

#29 Childlike Creativity

Kindergarten Teacher of the Year and Scholastic consultant Andrea Spillett-Maurer had her students create a collage inspired by beloved children's author Eric Carle, who wrote the enormously popular *The Very Hungry Caterpillar.* She was pleased to see how this open-ended assignment engrossed the children. They used paper with different colors and textures to create Carle-esque characters, overlapping various shapes to convey different aspects of each character. In the end, the students were beaming with pride, obviously empowered by what they created. This begs the question: Why can't we as adults empower ourselves by engaging in something that seems so simple but can be turned into something meaningful?

Step 1 Choose a word that you want to express, such as *love;* a personal philosophy such as, "Live every day to the fullest;" or make a personalized gift for someone special.

Step 2 Have an assortment of papers, glue, scissors with varied edges, magazines, markers, and oil pastels readily available.

Step 3 Allow yourself to become kidlike and let your hands follow your heart. As Andrea says, "The key to unlocking the creative spirit is freedom!"

—L. K.

#30 Feather the Nest

When interior designer Shelly Becker Cornelius is planning a mural for a client, she puts herself in the client's shoes and tries to find out as much about the person as she can. "What would he or she want to see each day?" is the question always at the front of her mind. One pair of clients requested a piece for their new baby's nursery: a close-up of a bird's nest propped in the nook of a tree, drawn from the perspective of a bird. After getting well acquainted with the couple, Shelly painted the nest as they wanted and added a long strand of paper with their wedding vows on it. It looked as if the mother and father bird had collected the strand and feathered the nest with it. Shelly suggests adding a surprise personal touch to your work. Not only was her client wowed by her effort, but it also demonstrated that she was really listening and that the creation was all about their desires. —L. K.

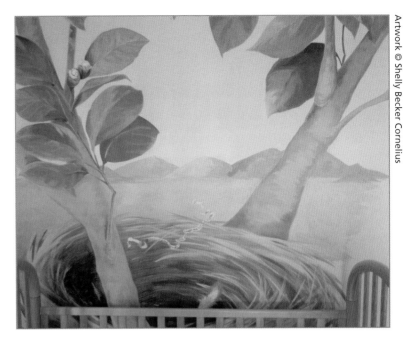

Artwork © Shelly Becker Cornelius

#31 Subordinate Hand

Attempt to draw a person, animal, or still life using your non-dominant hand. What do the distortions of your more "childlike" hand reveal? Oftentimes, trained eyes functioning through an untrained hand result in something refreshing and charming. It's amazing to see how the same brain and eyes can contribute to such different drawings. Much like a professional baseball player swings a bat over and over again until mastery is achieved, it takes practice to train your hand to draw.

—A. R.

#32 Roll Call

Begin a list of artists whose work you love and make some notes about why you're attracted to their art. Be specific about what draws you to their images. Is it the subject matter? Do you admire the way they use color, patterns, or shapes? Is it their raw childlike manner of expression, or their highly trained and polished rendering skills? An inspiring list like this is helpful to refer to when you hit a creative wall. —A. R.

#33 Offset Your Vision

Consider cutting a shape out of a section of your art and placing it elsewhere on the piece as artist Christopher Scardino does. You can try experimenting with multiple removals, different shapes, and relocations. Note whether or not the amendments change the story. Then ask yourself if the void speaks to you or frees your imagination.

—L. K.

#34 Spice Up Your Experience

Pamela Marsden, set decorator and Program Director for the Chuck Jones Center for Creativity, challenges you to rummage in the spice cabinet and be inspired by the smells, colors, and textures. Do the various aromas make you think of far away places? Do certain colors remind you of long lost memories? Incorporate spices in paint and start experimenting! —L. K.

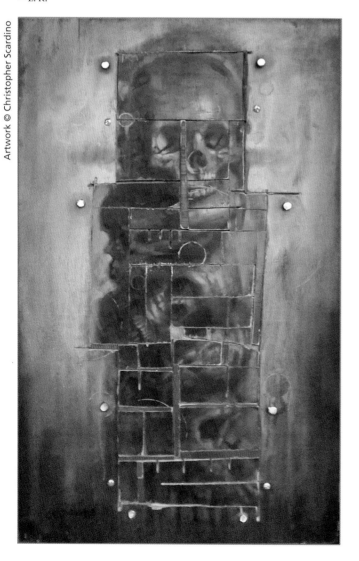

Artwork © Christopher Scardino

Photo © Dean Díaz

#35 Shakiba Hashemi

Biography: Painting provides me with the freedom I have yearned for all my life. I was born in Iran, in a strict and oppressive culture, where the people are deprived of even the most basic human rights. Coming to America gave me some relief, but I was still missing a deeper sense of freedom. It was only when I discovered painting that I felt content and at peace.

Q: Where do you find inspiration for your artwork?

A: I usually find inspiration in nature. I try to look at my surroundings with a fresh eye and take mental pictures of inspirational changes: watching the rays of the sun dancing through the clouds after the rain, watching hummingbirds flying around the rose bush.

Q: What do you do when you get artist's block?

A: I look at the work of artists I admire and listen to Chopin. The music distracts me enough to make new breakthroughs.

Q: How do you challenge yourself in the studio and avoid repetition?

A: I avoid repetition by changing the way I start a painting. I also try to experiment with different mediums, surfaces, and formats. These differences force me to react and push off into another direction that I haven't been before.

Q: What advice would you give to a blocked artist?

A: Relax. Breathe. Do not try to force it if it doesn't happen naturally. Don't feel guilty about not painting. Take a break for a few days and start up again when you receive inspiration.

Q: What artist/s or designer/s do you admire for their creativity?

A: I admire artists who are honest with the viewer and don't try to change their vision in order to be financially successful, e.g. van Gogh.

Q: Can you remember a class or an assignment from art school that challenged your creativity and possibly helped to redefine your aesthetic or thinking? If so, what was it?

A: We had to pick three masterpieces from three different artists and combine them into one scene. It taught me to think about structure and composition and shape/size relationships. —L. K.

Artworks © Shakiba Hashemi

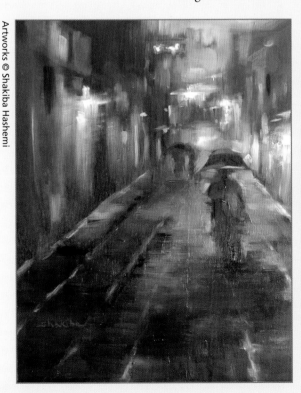

#36 Stand Up

Artists aplenty have used political issues as subject material for hundreds of years. Asking yourself which political issues matter to you may result in ample material for a new type of work. What are you passionate about? Perhaps the economy, environment, or the education system concerns you. Do you respond emotionally to animal welfare issues or racial inequality matters? Political topics close to your heart can open the door to a personal and profound body of work that either protests or reinforces the status quo.

Ya'el Pedroza creates artwork that challenges viewers to consider their role as consumers of mass-produced, disposable goods and the impact their choices have on the earth. Her work is layered with the duality of hope and despair as human-made waste and organic forms struggle for dominance. —A. R.

Artists to investigate:

—Francisco de Goya

—Judy Chicago

—Barbara Kruger

—Kerry James Marshall

—Kara Walker

—Coco Fusco

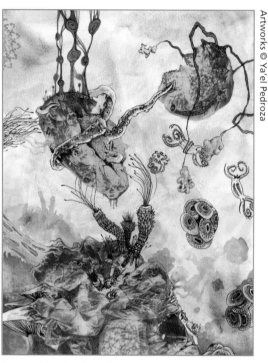

Artworks © Ya'el Pedroza

Islands #2, mixed media, 11"x15", 2009

Islands #1, mixed media, 11"x15", 2009

#37 **Rising Star**

Many artists make a living by painting famous athletes, celebrities, or historical icons. Picture Andy Warhol's Marilyn Monroe, Norman Rockwell's Santa Claus, or a black-and-white portrait of Marcel Marceau. Choose a modern-day celebrity who best represents you (e.g. soccer star David Beckham, Bollywood sensation Aishwarya Rai, or rock star Bono of U2) and use that person as inspiration for a creative work. Think about what your choice and how you render your chosen icon say about your creative method. —L. K.

INSPIRATION

#38 **The Deep Simple**

Mundane objects woven into our everyday lives serve as great themes for a large body of work. Assess the objects and types of objects you see and/or use on a regular basis. Is there something that reveals profound concepts about your life or the human condition in general, in spite of its relative simplicity? In presenting still lifes to a viewer, it's possible to present many different ideas using simple objects. Choose a type of object and explore all of its visual possibilities: change the environment, orientations, and lighting conditions.

Nathan Rohlander's shoe series investigates the concept of portraiture without depicting a person directly. The accessories people choose to adorn themselves with speak volumes about their personalities. By painting a portrait of people via their shoes, Rohlander asks the viewer to consider an object the extension of a person. The wrinkles, scuffs, and creases in shoes from wear and tear impart intimate knowledge of the wearer to the viewer in a way that previously only the eyes could convey. —A. R.

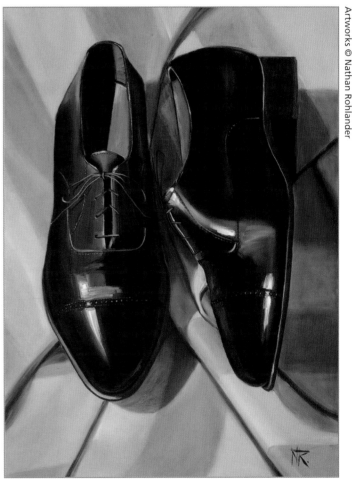

Artworks © Nathan Rohlander

To The Nines, oil on canvas, 48" x72", 1999

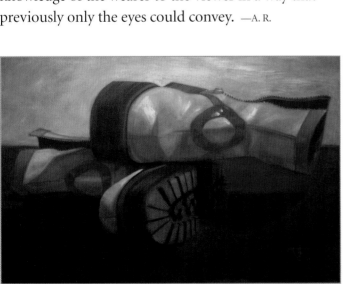

Geo, oil on canvas, 48" x 72", 2000

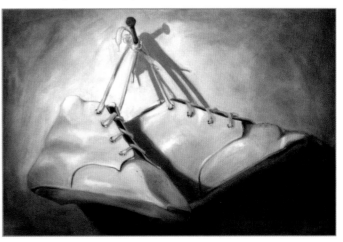

Memories, oil on canvas, 48" x72", 1999

#39 Hop, Skip, Jump

Sandie Glass, an innovation expert and creative catalyst for global brands, suggests the following activity to jumpstart your creative juices:

Step 1 Write each of the following action items on individual strips of paper:

Walk, Add a New Color, Wrap Around, Trot, Stop Short, Zig-Zag, Bunny-Hop, Reverse, Jumping Jacks, Slither, Make Smaller, Skip, Sneeze, Turn Upside-Down, Run in Circles, Zoom Ahead, Be a Yo-Yo, Accelerate, Fall Down, Expand, Sharp Left Turn, Kick the Ball, Laugh Out Loud, Be Playful, Turn Inside-Out, Pop the Balloon, Fly a Kite, Get Excited, Blow a Bubble

Step 2 Fold each strip of paper so you can't see the actions, place them in a bowl, and mix them up.

Step 3 Using a paintbrush, begin to draw a line on the canvas. Then randomly select a piece of paper and make that line do the action on the canvas. —L. K.

Here's what you'll need:
- Plain copy paper cut into strips
- Medium-size bowl
- Paintbrush
- Acrylic paint
- Canvas board

#40 Word Search

When Strategic Branding Expert at Reynolds Design Group Carrie Reynolds suffers a block, she Googles words. For example, if she needs a theme for a spring event, she Googles "spring fashion reports," "spring break events," or "spring flower shows." Carrie then makes a list of words from all of these sites, from reporters' updates, and from "other writers more clever than myself!" This list of words, ideas, pictures, and different approaches to the same idea always generates a whole new world of inspiration! —L. K.

#41 Drawing Evolution

Draw something in your sketchbook. It can be anything—a person, place, animal, or object. Write three descriptive words about it, like how it feels to the touch, what kind of personality it may have, what basic shape it is, etc. Now try coming up with another object that shares those attributes and draw it. Then, come up with three more descriptive words about that object, and draw another object that shares those attributes. Continue this process until you have at least five different drawings. —A. R.

MENTAL EXERCISES

#42 **A New Angle**

If you're stuck on a piece of two-dimensional art that needs something, but you don't know what, try turning it upside down or on its side and analyze it that way. Observe it from across the room, or move it to another room with entirely different lighting. Then take a photo of it, import it into the computer, and look at it as a thumbnail icon. Regardless of whether the work is representational or abstract, you'll feel a sense of detachment from the piece. Your expectations for it will fade, allowing you to assess what it needs in the way of colors, values, and shapes. —A. R.

ASSIGNMENTS

#43 **Totem Pole**

Your life is a series of memorable events embedded in your brain. When you ponder the past, emotions and memories come to mind. Imagine each major event stacking upon the next until you've created a memory totem pole. Begin by first sketching the images and then stacking them. Your images can be scenes, or simply faces displaying emotions. —L. K.

INSPIRATION

#44 **The Art of Children**

Attend a community art exhibit or a back-to-school night at an elementary or high school.

Pay close attention to the art that is displayed, as well as the age or grade level of the artist. —L. K.

Artwork © Mrs. Andrea Spillett-Maurer's Kindergarten class

#45 **Tapping the Spiritual**

Artists have used spiritual and religious subject matter in art for thousands of years. Images of such religious icons as Jesus and Buddha are an obvious resource, but how would you create work that reflects the more abstract, transcendent nature of the spiritual self? Is there a specific place that makes you feel unified with the Divine in a physical or mental sense? What does that look like? Exploring an agnostic or atheistic point of view holds equal value. Questioning the social constructs of belief provides rich subject matter for many contemporary artists. Remember to look at the issue from both a personal and a global vantage point.

Mia Tavonnatti's paintings and mosaics explore her personal conversation with the Divine and the transformative process of awakening to the love of self, beauty, and the mysteries of life. In her images, light appears to nurture gently resting or floating figures enveloped in gossamer veils or clear blue water, symbolizing the way she, as an artist, searches for and discovers personal spiritual truths beyond the veil of tangible reality.

—A. R.

Artists to investigate:
–Wassily Kandinsky
–Mark Rothko
–John Feodorov

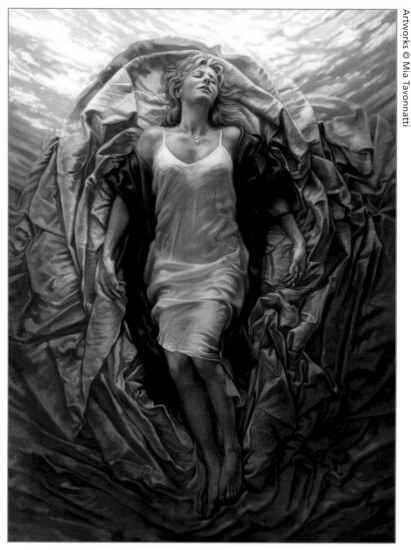

Emerge, oil on canvas, 43" x 32", 2006

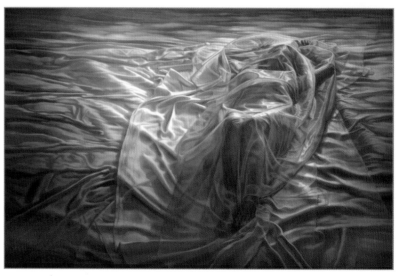

Shroud, oil on canvas, 66" x 96", 2006

Santità, oil on canvas, 32" x 44", 2007

#46 What's That Song Look Like?

Listen to various types of music: classical, jazz, pop, or rock. Then create three different paintings based on each song or genre. Paint while the music is playing; don't be influenced by anything else. What colors and shapes best represent the sounds? Imagine that the music has a texture and choose the brushstrokes and marks that represent its tactile quality. There is no right or wrong. Simply express the first images that come to mind. —A. R.

Here's what you'll need:
- Watercolor or acrylic painting materials
- Watercolor paper or canvas board

#47 Did You Know?

The average child can come up with sixty alternatives for any situation. The average adult can think of only three to six.

#48 **Ink and Bleach**

This is a fun, if not unpredictable, process that requires a little bit of experimentation and practice.
Caution: Bleach isn't safe to inhale, so work in a heavily ventilated area. When not using the bleach, keep it covered to minimize fumes.

Here's what you'll need:
- Dye-based ink of any color
- Household bleach
- Large watercolor brush
- Cheap brushes

- Paper (heavy-duty rag or watercolor paper works best, but you can use canvas if you prefer)
- Small jars
- Paper towels
- Rubber gloves (optional)

Step 1 First, wash the entire ground of your picture plane. Dilute your ink with water to create a transparent wash or a flat wash of solid ink. By washing the ground with clean water first, the surface gets wet enough for the ink to bleed. For this painting, two different colored inks were washed in opaquely and bled into each other while wet.

Step 2 After the wash dries, dip roughly cut fabric circles into heavily diluted bleach (ten parts water, one part bleach). Next, press them onto the background to create a subtle textural effect and add dimension to the final painting.

Here, a string of puffballs dipped into pure bleach creates a line pattern throughout the piece.

Step 3 You can dip anything into bleach and make a print of it.

Step 4 In this image, the line pattern was burnt out of the ink background, so more negative space was needed. Try using an old paintbrush to apply pure bleach directly onto the paper and in between lines to create flat shapes.

Step 5 The bleach dries quickly, especially outside. Now it's time to embellish the drawing with your media of choice, or consider it complete. Here, acrylic paint and white charcoal polish it off. —A. R.

#49 Reincarnated

Draw, paint, or sculpt a portrait of yourself in the guise of an historical figure that intrigues you. You could be Joan of Arc, Martin Luther King Jr., or even an Egyptian pharaoh. Begin by finding out as much information about the imagery that served as a backdrop to your subject's noteworthy life to enrich your artwork. Research the landscape and architecture, textile and jewelry designs, dress, and any other paraphernalia in the culture and era of your chosen figure. The artwork can be direct (superimposing your

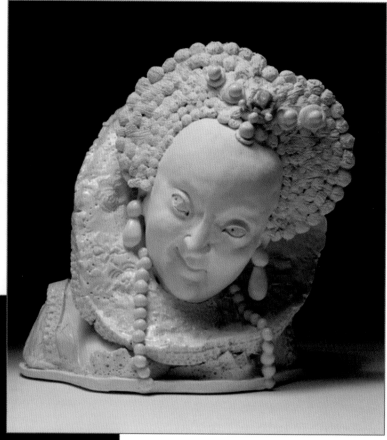

Portrait of the Artist As Queen Elizabeth I, partially glazed white stoneware, 8"H x 7"W x 5"D, 2008

face on a representation of your subject) or abstract (blending symbols representative of your subject and yourself together).

Contemporary ceramic artist Alice Simpson's *Portrait of the Artist* series of clay sculptures features her likeness imagined as several noteworthy figures or as a physical manifestation of an artist's work. Each piece is laced with symbols that allow the viewer to easily grasp the subject of the portrait, yet clearly depicts the face of the artist herself. Whimsically exaggerated expressions add another layer of meaning, as her work often asks viewers to reconsider themselves in the context of history and art.

—A. R.

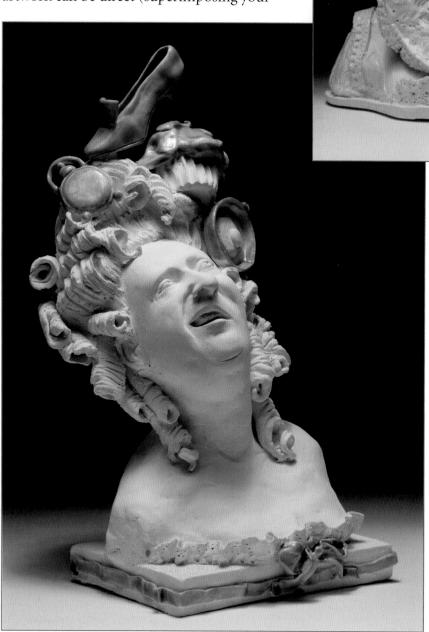

Portrait of the Artist As Marie Antoinette, partially glazed white stoneware, 11"H x 6"W x 6"D, 2008

#50 Change it Up

Travel! Go to the opera. Try a new restaurant. Do something outside of your usual day-to-day life. If you spend your weekends as a homebody, try going out and seeing something new. It doesn't have to be a far-off destination; it could be a new place just down the street. I took a trip to an aquarium and was so inspired by the beautiful, jewel-like color palette of the aquariums themselves that I came home and started a painting based on those colors. I had no idea I'd get a painting out of that trip; I just thought I was going to look at fish! The amount of inspiration lurking within the landscape of new destinations can catch you off guard, so bring your sketchbook and camera wherever you go.

Here are some ideas to get you headed in a promising direction: aquarium, amusement park, concert hall, science museum, site-specific local attractions, zoo, urban center, farm, nursery, landscape curiosity, local theater, art gallery, observatory, cathedral, public art site. —A. R.

#51 Tattoos and You

Tattoo art dates back to Neolithic times but was popularized by the Polynesian culture. Throughout the ages, these etchings on skin have been used to identify people, preserve family history, and celebrate various rites of passage. Each work of art tells a story, declares a way of life, and expresses creativity. If you don't already have one, sketch or paint your imaginary tattoo(s). If you do have one, what would you like to add to your body, and where would you put it? —L. K.

#52 Excavate Your Past

Memories. You have an entire history of life behind you, and that history is invaluable resource material. Think of the moments in your life that stand out as emotional landmarks. What significant moments have played a role in sculpting your personality and world view? Ponder what that moment or series of events look like as one or several images, as well as what objects, faces, symbols, or colors come to mind when you think of that time.

Jana Rumberger's work uses her personal history as a way to explain the biological processes of memory. For twenty years she recorded the activities of each day in her own handwriting on calendars. Eventually that documentation ceased and metamorphosed into a piece of installation art. By cutting

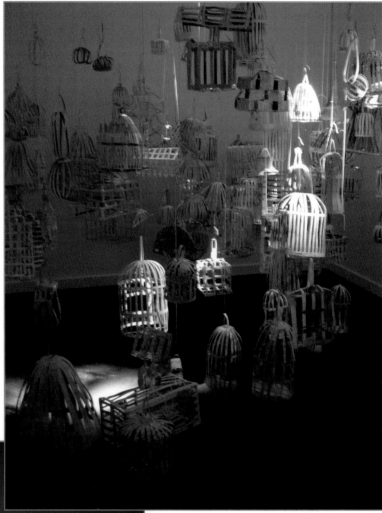

Photo © Jana Rumberger

▲ Installation, mixed media, 12' x 12' x 14', 2007

up the calendars and making them into birdcages, Rumberger comments on the obsessive need to record the daily events of life, while simultaneously deconstructing the impulse to hold on to the past. —A. R.

Artists to investigate:
—Tracey Emin
—Arturo Herrera
—Shahzia Sikander

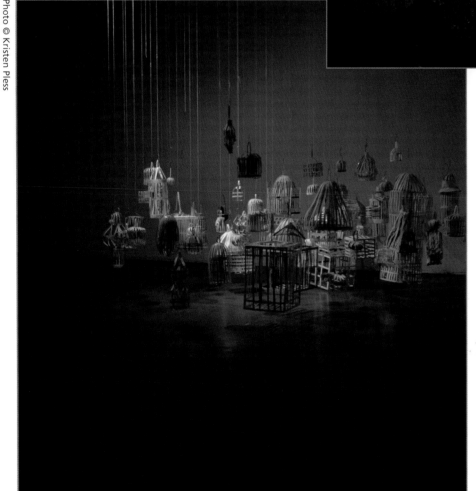

Photo © Kristen Pless

◄ Installation, mixed media, 12' x 12' x 14', 2007

#53 Letting Go

If you're working on a piece of art and feel a creative impulse, follow it, even if it means erasing, painting over, or destroying an aspect of the work. What matters is that the final product is the best that it can be, not that you spent hours on a particular part that simply isn't working. Sometimes, creating also involves destroying. It's painful, yes; but if the work ends up stronger, it's worth it! —A. R.

Tip: Placing clear acetate or tracing paper over a piece of two-dimensional artwork to draw or paint a new idea on it helps work out problems with the piece without destroying anything on the artwork itself. It's a less permanent way of problem solving.

#54 Blue Sky

When is the last time you daydreamed? Take a blanket or beach towel and your favorite sketchbook to a quiet field or park. Lie down on your back and gaze up into the sky as you breathe in the fresh air. Open yourself to the infinite while you let your mind drift. What images appear? What ideas come to mind? What tickles your heart? —L. K.

#55 Yin and Yang

A world of color surrounds us, from blue skies and robin eggs to orange-red sunsets and mango salsa to purple lilacs and eggplant. It's these simple but beautiful objects that often inspire still life or watercolor paintings. Taking inspiration from the symbol Yin and Yang (a theory of Feng Shui, the Chinese perspective of balance and continual change), find a vivid, colorful subject and use only black and white to capture what you see. —L. K.

Artwork © Shelly Becker Cornelius

#56 Superheroes

Imagine yourself as one of your favorite superheroes, or a superhero of your own creation. Which secret powers do you possess? Also consider your superhero attire and accoutrements. Do you have special clothing, a magic wand, or an indestructible vehicle? After you've rounded out the characteristics of your alter ego, paint or sketch as if you were that person. —L. K.

#57 Brian Thompson

Biography: Brian Thompson is the Art Director for Big Fish Games' *Drawn* adventure series. He establishes, directs, and maintains the visual style of *Drawn* as a brand. He also collaboratively designs the game play and story/narrative of the series. He is the author of the feature article "New To Games, A New Vision," written for online gaming magazine Gamasutra. Brian is a graduate of Art Center College of Design in Pasadena, California, and holds a Bachelor of Fine Arts in Illustration with distinction.

Q: Where do you find inspiration for your artwork?

A: Most of my inspiration comes from my childhood. My brother and I had lots of room to explore, and I owe much of my vivid imagination to our adventures. I feel like I genuinely look at the world through childlike eyes. Animals, people, places—they all seem surprisingly new and different even if I have seen them countless times. I love the way that children experience the world and how they express their thoughts and feelings. My three-year-old daughter Cora and my one-year-old son Brooks have been a constant source of inspiration while developing *Drawn*.

Q: What advice would you give to a blocked artist?

A: Stop trying so hard. Give yourself some room to play, experiment, and fail. You'll never find new creative territory otherwise. Find an artist you admire and try to emulate their use of color, mark making, or compositional style. Don't feel guilty; you'll be amazed at how inspirational this can be. More often than not it will lead you to some really great discoveries of your own.

Q: How do you balance your creative impulses with making work that consumers will buy?

A: I have found that the more you follow your creative impulses, the more successful you will be. Impulses are fleeting, gut-level gems, and more honest than most premeditated endeavors. We all like the familiar but we need the new and different. Yes, I want customers to buy my product and love it, but I also want to give them something they didn't expect and didn't even know they wanted.

Q: Can you remember a class or an assignment from art school that challenged your creativity and possibly helped to redefine your aesthetic or thinking? If so, what was it?

A: At Art Center College of Design I studied with Dominick Domingo. One question Nick said to ask yourself is: "What do you want the viewer to feel?" This is a simple question that should have a simple answer supported by simple ideas: Is the scene warm or cold? Is it day or night? Is it static and calm or active and dynamic? Is the scene bright or dark? Where is the light coming from and why? Nick taught me how to simplify my thinking, not get overwhelmed, and always bring it back to storytelling and emotion. —A. R.

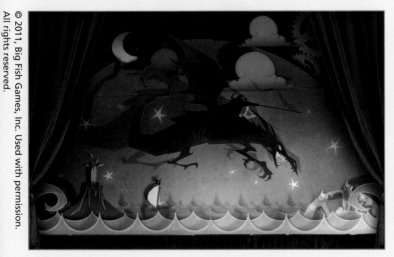

Dragon

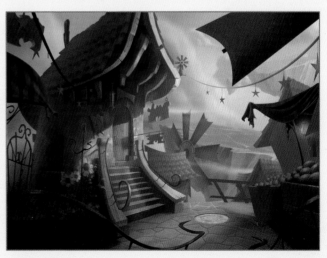

Windmill City

#58 **Five-Ingredient Fix**

How many colors, media types, or embellishments do you usually use in a project? Follow the advice of scrapbooking enthusiast Carolyn Miller and limit yourself to only five items. Create from there. You might be surprised by how liberating it feels. —L. K.

#59 **Collage and Draw**

Find an engaging image—or part of an image—in a magazine, cut it out, and paste it into your sketchbook. Now add on to the image with a drawing in pencil or pen. Try not to over think it; just respond visually to what you see. —A. R.

#60 Did You Know?

In his early years, Pablo Picasso had the good sense to exercise determination in detention: "For being a bad student I was banished to the 'calaboose'—a bare cell with whitewashed walls and a bench to sit on. I liked it there, because I took along a sketch pad and drew incessantly… I think I provoked situations so that professors would punish me. I was isolated and no one bothered me—drawing, drawing, drawing. I could have stayed there forever drawing without a stop. True, all my life I've been in the habit of drawing, but in that cell it was a special pleasure—difficult to explain. It's not that I wanted to excel, rather to work—that's what one must always do." —Pablo Picasso

ASSIGNMENTS

#61 Conceptual

Draw what you think any of these words look like: breathe, dream, believe, invent, wish, or love. Create representational or abstract drawings. Or try both! What do these words really look like and what do they feel like? —A. R.

41

#62 The Middle Man

Our physical relationship to the making of artwork has a lot to do with the aesthetic of the actual artwork. So, what would happen if we changed that relationship? Distancing yourself from your work can create some interesting results. This project can be done as either a charcoal drawing or an acrylic/oil painting. —A. R.

Here's what you'll need:
- 2-foot-long stick that doesn't bend, such as bamboo
- Charcoal or acrylic/oil paints
- Paintbrush (if using paints)
- Paper or canvas board

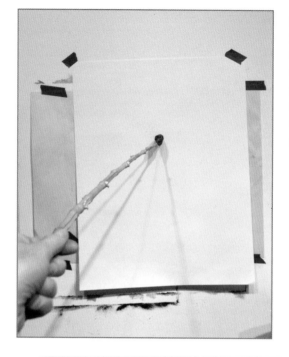

Step 2 Next, hang a piece of paper or canvas on the wall. On it, create a drawing or painting of anything you want while standing a few feet away and drawing with your arm outstretched.

Step 1 First, tape either a piece of charcoal or a paintbrush to the end of the stick and check that it's secure.

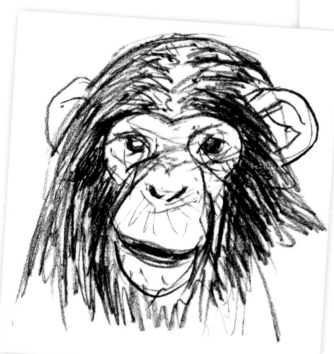

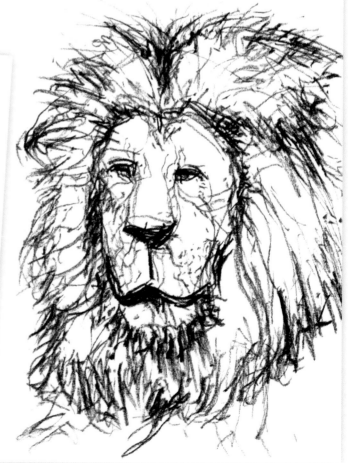

Step 3 Use your whole body to create this drawing. These two drawings used photographic references of a chimpanzee and a lion.

#63 Book Sense

Most bookstores—especially the large chains—have a section of books dedicated to art and artists. Go and browse the art section. There you'll find some of the latest books along with the classics. Many major cities boast a bookstore that specializes in art, architecture, and photography titles. Search the Internet for an art specialty bookstore near you, then go and see what you discover. —A. R.

#64 Do it Now!

Remember when you finger-painted in school with tempura paints? Think about the shapes you made and the colors you used. Now try it again and let your fingers be your paintbrush. What do you think of your finished product? —L. K.

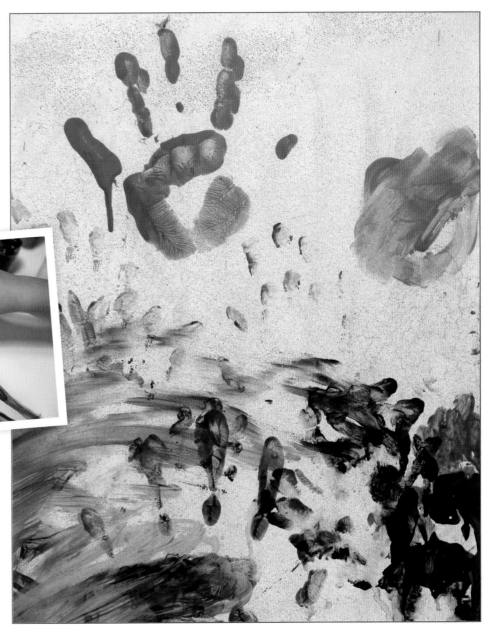

#65 Make Your Mark

Expressive mark making adds life to a drawing. An abundance of closely-knit lines create texture and value, while the character of the line and variation in line weight reveal personality. In this assignment, practice some standard mark making techniques like hatching (A), crosshatching (B), and stippling (C). Then experiment with your own mark making language. Every artist's hand "speaks" in a different way, so embrace the variations you come up with, whether it's swirls, squiggles, or something invented. Apply your marks to drawing any object you want. You can even use several different marks in one drawing for added visual interest. Also try experimenting with brush, pen and ink, and charcoal and ink on different textured surfaces. For inspiration, research Alberto Giacometti drawings, as well as the artwork of Cy Twombly, Vincent van Gogh, and Willem de Kooning. —A. R.

A. Hatching

B. Crosshatching

C. Stippling

#66 The Right Stuff

Interior designer, artist, and jeweler Krista Everage believes that eating right is one of the essential practices for maintaining and increasing the creative flow. To her a good diet means eating anything she wants, except for dairy, wheat, sugar, chocolate, alcohol, caffeine, added preservatives, and anything artificial. She chooses organic, humanely raised foods that keep her energetically connected to the universe and feeling the love that surrounds her. What can you add or subtract from your diet in order to better your well-being and heighten your creativity? —L. K.

#67 Why Do You Make Work?

Take a moment to analyze your impulse to create artwork. Do you do it because it's fun and you like to make objects with your hands? Do visual images or objects communicate your emotions and thoughts more clearly than any other mode of expression? Or is it simply that you find creating visual art relaxing and meditative? Answering the question "What motivates me to make artwork?" may give you focus with regard to your work's content. Jot down in your sketchbook why you like to create in general and why you like to make what you make. —A. R.

#68 Secret Stranger

Does it feel as though someone is stopping you from doing your best, most creative work? Perhaps it's the voice inside your head…or a tug at your heart? Discover unexplored aspects of your personality through maskmaking, an exercise inspired by Pamela Marsden, a set decorator and the Program Director for the Chuck Jones Center for Creativity. Once your mask is complete, paint or draw from the perspective of the person revealed in your mask.

Step 1 Start by sketching a rough mask shape you'd like to work with onto a 10" x 20" piece of cardboard. As you sketch, consider the mask's characteristics: Is it long and narrow with a pointed chin? Or maybe it has ears that jut out and a third eye. Is the mouth a grimace or a smile? Is the nose a wedge applied to the surface, or a flat piece inserted vertically? You get the idea.

Step 2 After you've sketched the mask and all its unique features, cut away the unnecessary parts of the mask leaving only the essence of your expression.

Step 3 Now for the fun part: embellishing! Embellishments can be anything that strikes your imagination. Try slashes or squiggles of cardboard to add dimension, or adding war paint or rosy cheeks. Strategically placed wedges of cardboard or other paper make great hooded eyelids and curled paper makes instant eyelashes. Here are a few material ideas for achieving the look of hair: jute, twine, yarn, paper curls, ribbon, fabric, palm fiber. Be inspired by everything around you, and have fun! —L. K.

Photo © Dean Diaz

#69 Creating Collage

Gather a random assortment of magazines; set a timer; clear your mind; then flip through the magazines, tearing out any page that speaks to you. When the timer goes off, sort through your pages and see if a theme emerges. Make a collage on canvas, a wall, or a poster board, and refer to it for inspiration. —L. K.

Artworks © Shelly Becker Cornelius

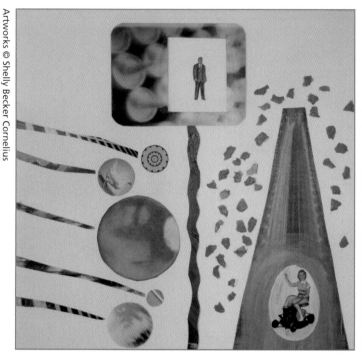

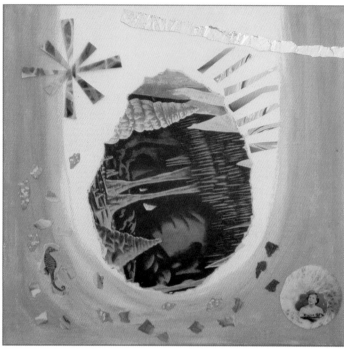

#70 Listen Up!

Do you enjoy the sultry strains of the saxophone, the jazzy sounds of rhythm and blues piano, or perhaps the pulsating beat of techno? Whatever gets you moving, crank it up on the stereo and try to translate the raw emotion of those instruments and beats into color. —L. K.

#71 See for Free

Many large art museums periodically offer free admission. Search the Web or call your local art museums to find out if they offer a free day and take a trip! Looking at art in person always results in a wealth of inspiration. When finances are tight, free days are a great option. —A. R.

The Louvre Museum, Paris, France

#72 Nu View

Have a friend put an assortment of everyday objects (e.g. a feather boa, a colander, a wig, a wooden spoon, a boot stretcher, etc.) in a large bag. Pull one item out of the bag and think of as many different uses for the object no matter how crazy it is. Tuck your bag away for another day when your ability to rethink, reinvent, and stretch your imagination needs fine-tuning. —L. K.

#73 A Space of One's Own

If you don't have a studio space, designate an unused corner of a room as your thinking hub. Get a comfy chair and hang images that inspire you. If you have a lot of distractions in your home, hang fabric around the space to block some of the extraneous visual noise. Make it your own and let it be known that you are not to be disturbed here! Having a personal space to read and explore ideas uninterrupted is incredibly valuable to the creative process.

—A. R.

#74 Body Parts

You won't be painting a crime scene…so try painting or sketching with one of your body parts—a foot, your tongue, or your hair. Also try putting a pen or paintbrush in your mouth or between your toes and observe the way your expectations change along with your newfound technique. For more adventurous folks, explore ways to paint your various body parts or one of your friend's body parts. (Be sure to use non-toxic paints!) —L. K.

#75 Do it Now!

Put your paints in a bag. Without looking, pull out three colors, plus white. Create a painting using only those colors. —L. K., inspired by artist David Fairrington

#76 **Culture Question**

Pick a place on the globe, anywhere you think you'd like to visit that is very different culturally from where you're from. Now do a little research on the visual history of that culture. What do their textiles and art look like? Explore their ceramics, traditional dress, jewelry, and festival or ceremonial decorations. How does that culture adorn their places of worship and their homes? Hone in on the images that inspire you and think about how you could use a pattern from one of their tile floors or traditional blankets in a drawing or painting. Scan images from books or print images from web sites that speak to you and glue them into your inspiration book or sketchbook. —A. R.

Portrait of Sumburu woman wearing traditional handmade accessories

Islamic tile patterns

Indian Bride

Whale in Native Pacific Northwestern Style

Ukrainian hand-painted Easter eggs

Vase in traditional Chinese style

#77 **Gumby**

Paint a simple object and then stretttccchhh your imagination by stretching your image, shrinking your image, making it fly, making it float in water, making it become human. You're only limited by your mind's eye. —L. K.

#78 **Non Sequitur**

Choose ten numbers. Next, get a book or periodical, choose any paragraph, and start counting the words according to your number list. For example, if your numbers are 6, 10, 2, 24, etc., count to the sixth word in the paragraph and write it down, then the tenth word, and so on. The result is a ten-word non sequitur sentence. Illustrate the sentence in your sketchbook. —A. R.

From Giorgio Vasari's *Lives of The Artists* came "Who the his Giotto Chapel river-front at St. Lucy stones." So here is St. Lucy standing in a river in front of the Scrovegni Chapel, whose walls are covered with Giotto frescos.

#79 **Magical Moments**

You've experienced it…that magical moment that sparks the imagination, that glimpse of something new and unique, that moment when a new awareness of something produces the passion and energy to explore and create. It could be a moment in time, an awakening, a remembrance, or an exceptional experience alone or with a companion. Perhaps it comes in the form of a vision, a view, a feeling—day or night, awake or sleeping. Maybe it appears in the sky: a cloud, shadow, reflection, or light. The spark and energy are kindled and the imagination draws you further into a creative space. Be inspired by light and try to express all its qualities, its source, and its energy. —L. K.

Draw upon snippets of time that have never left your memory.

On a recent trip to Italy the artist was invited to lunch at the home of a local count. The light in this beautiful courtyard was especially perfect that day.

Artworks © Juliette Becker

#80 **Did You Know?**

We dread mundane tasks, but it's those tedious time-consuming things that often spark impromptu brainstorming sessions and result in new, exciting ideas! People are often inspired while driving, so remember to keep a blank book in your vehicle. (Just remember to pull over before jotting down your thoughts.) Don't be surprised if you also strike creative gold while cutting the grass, vacuuming, ironing, showering, or when you're sitting on the toilet. —L. K.

#81 Christopher Scardino

Biography: Christopher nurtured his intellectual curiosities by delving into anthropology and sociology before understanding his right brain. After the loss of his father, he vowed to devote his life to something meaningful—art. Three years after he drew for the first time, Christopher graduated Summa Cum Laude from Laguna College of Art + Design in Laguna Beach, California, with a Bachelor of Fine Arts degree. He studied painting under Stephen Douglas and theory under Thomas Stubbs and now devotes his time to further exploration into the realm of expression in its myriad forms.

Q: Where do you find inspiration for your artwork?

A: The natural landscape, with all of its colors, textures, and undulations. In most cases, I attempt to utilize what I experienced on a particular day to inform me about what I would like to express. Inspiration comes from a weed fighting its way through a crack in the pavement or gentle wafting of air that allows a leaf to fall rhythmically to the soft ground. My wife inspires me to create something beautiful and sometimes I do.

Q: What do you do when you get artist's block?

A: I scratch out some quick drawings or break everything down to its simplest component, including myself. Childlike activities usually do the trick. Play with blocks, cut paper like a bedridden Matisse, or paint with your fingers. A block is only created when useless information overcomes the beautiful ideas. We need to sort and file the pertinent data and disregard the rest.

Q: How do you challenge yourself in the studio and avoid repetition?

A: I avoid repetition like the plague by working on different surfaces, shapes and sizes, and certainly different media. Being a mixed-media/abstract artist, every time I create an art piece I am intertwined in a complex web of challenging instances that require order to be found through the chaos. Challenge is a great term; grab three disparate elements and attempt to make sense of them.

Q: What artist/s or designer/s do you admire for their creativity?

A: Rembrandt, Velásquez, Sargent, Hals, Corbett, Diebenkorn, Rothko, Picasso, Matisse, De Kooning, prehistoric cave painters. I am drawn to soft, painterly edges and letting the spontaneous gesture overtake the art.

Q: How do you balance your creative impulses with making work that consumers will buy?

A: I rarely think of whether or not something would be easier to sell if I take a certain road. That said, whenever I attempt to shift my art to the level of mass consumption the piece lacks substance and my personality seems limp and lifeless, so I destroy it.

Q: Can you remember a class or an assignment from art school that challenged your creativity and possibly helped to redefine your aesthetic or thinking? If so, what was it?

A: The art school I attended was very technical and left very little room for spontaneity but there were a few moments in the methods and materials class that enlivened my sense of discovery. We mixed our own pigments and binders, prepared surfaces for silverpoint, and engaged in etching and encaustic. It felt like I was firmly connected to the great epochs of Renaissance and Baroque Art. This may be why I prefer to mix media and try my hand at something different almost every time I flip the switch in the studio. —L. K.

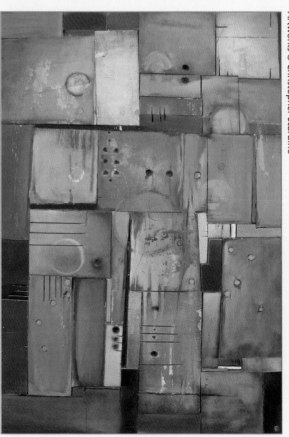

#82 Garden

Try your hand at designing with flowers. Organizing a garden is both a therapeutic and highly creative endeavor that requires harmony of colors, textures, and shapes, as well as proportions of flowers, leaves, stems, and other elements like rocks and pots. You don't need vast amounts of acreage to enjoy gardening; a modest deck or even a windowsill allows for a small arrangement of potted plants. The act of designing a garden is really a twofer, considering you'll have great subject matter to draw and paint from, on top of a lovely area where you can think about your next art piece. Go beyond the obvious and think deeply about how you intend to lead the viewer's eye throughout. Create a focal point. Control the scene. Make lines and shapes by grouping plants together. Consider positive and negative spaces. Finally, observe the ways areas of flowers resemble abstract paintings. —A. R.

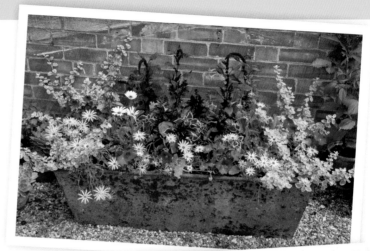

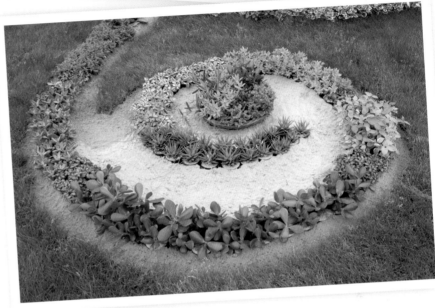

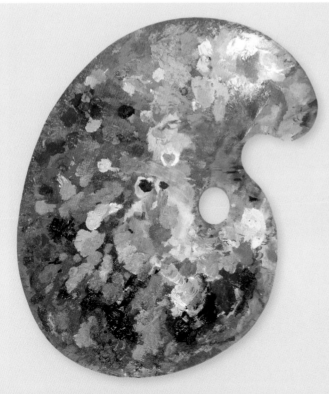

#83 Picture This!

While dining at a friend's house I was introduced to the work of celebrated artist Steve Penley, whose work appears in collections at the New World of Coca-Cola in Atlanta, Georgia; ESPN Zone in Atlanta, Georgia; and the Federal Reserve Board in Washington, D.C. Steve is renowned for his vibrant paintings of such historical icons as Ronald Reagan, as well as his ingenuity. In a dinnertime anecdote, I learned that he turns his weekly palette into a portrait of Jesus Christ, the print hanging in my friend's home. After a week or month of painting (depending on frequency), try turning your palette into a recognizable image. —L. K.

#84 **Blind, Sing, Draw**

Choose a favorite piece of music, preferably one that you love to sing to. Get a pencil and paper. Close your eyes, and sing along to the song while drawing. For clarity, stop yourself after the chorus, open your eyes, and look at what shapes have developed. Keep going if you need more. Whether it results in something abstract, representational, or merely scribbles, this exercise is a great warm-up for getting into the studio. —A. R.

#85 **Time Traveler**

Imagine you're drawing from different historical perspectives. Go back to the Prehistoric Ice Age and think like a Neanderthal man. What would you draw in your cave with your crude stone tool that would convey your feelings about seeing fire for the first time? Next, travel to the Roman Empire and imagine being a spectator at the Colosseum. What images come to mind? Then, take a trip to Ponce de León in search of the Fountain of Youth. What do you see, hear, and feel? Now jump to the year 2060 on a NASA spacecraft to another world in the solar system. What do the dark recesses of space hold? What do you find when you land on the surface of the planet? —L. K., inspired by strategy, insight, and innovation expert Sandie Glass

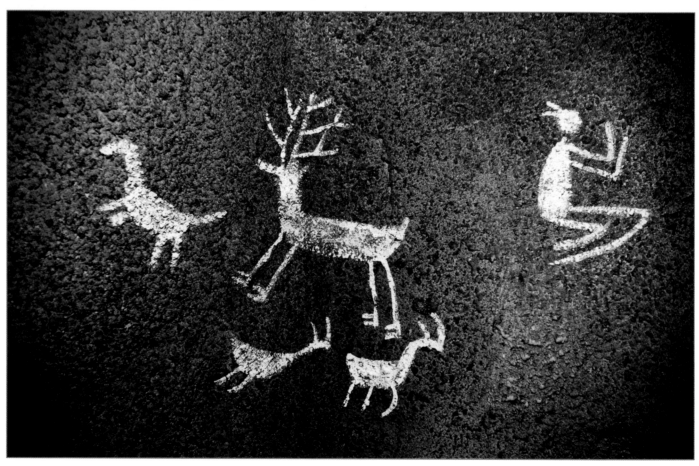

#86 Saturday Morning

When she feels stressed and in need of an attitude adjustment, Pamela Marsden, a set designer and the Program Director for the Chuck Jones Center for Creativity, watches a Chuck Jones cartoon. It's an entirely different experience for her now, as compared to when she was growing up, but it brings Pam back to Saturday morning fun, watching television with her brothers. At her workplace, board meetings often commence with a cartoon! Pam's personal favorite is "Robin Hood Daffy." What songs, shows, or images take you directly to your happy place? —L. K.

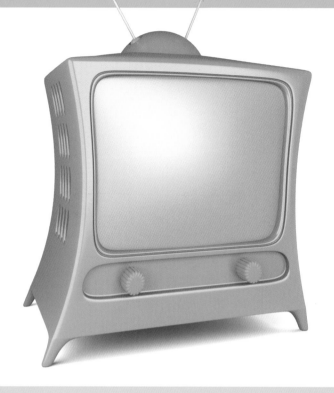

#87 Endurance Drawing

Live in your art! A work of art's scale greatly impacts how the maker and viewer perceive it. Begin this exercise by starting a drawing of anything on a piece of blank paper and tacking it to a wall in your workspace. Each day add a new piece of paper to the drawing and continue the previous drawing. The continuation of the first drawing is analogous to an idea that evolves each time you think about it, as opposed to a collection of several distinct drawings. The drawing itself can be as direct as expressive mark making, or can reflect the objects, people, pets, and emotions in your immediate environment. Extend the drawing both in height and width for as long as you can, letting it consume your space. Take time to reflect on how the drawing and your perception of the previous drawings changes each day. How do the drawings on the wall affect your thinking about the other artwork you're creating?

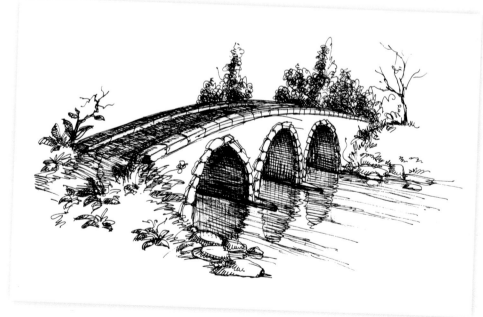

This assignment is about dedication. It's about continuing a dialogue with yourself, even if you're sick and tired of it. Push through ennui and laziness, and draw every day. Allow confrontation with your own thoughts and talk to yourself in lines, shapes, and values. —A. R.

#88 My Ride

Choose a brand of vehicle that best fits your persona. Are you a hybrid car, a beefy Harley-Davidson® motorcycle, a Ferrari, or a vintage Chevy truck? Think about your choice, and explore the ways your mode of transportation reflects your approach to creative endeavors. —L. K.

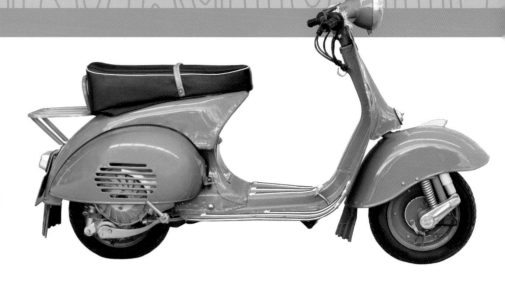

#89 Color Fields

Revel in the pure joy of color by creating small collages using simple large fields of color. Balance big bold shapes and small delicate shapes against one another. Make collages with only bright, intense colors and some that are more muted. This exercise frees the mind of thinking about content and allows the artist to explore using favorite colors and abstract shapes with immediate gratification. Simply glue cut pieces of paper to Bristol board for support. —A. R.

Here's what you'll need:
- Several sheets of art paper in different colors (Color-aid® paper or fade-resistant construction paper)
- Bristol board
- Pencils
- Scissors
- Small straight-edged knife
- Archival glue stick

Art and artists to investigate:
–Late Matisse collages

–Hans Hoffman

–Mark Rothko

–Josef Albers

–Morris Louis

–Helen Frankenthaler

#90 Value Collage

As you begin this assignment, think of value shifts as simple shapes.

Step 1 First, put together a simple still life, or choose a subject from a photograph with clear value changes.

Step 2 Next, make a line drawing of the subject. Draw the major values (white, light gray, medium gray, dark gray and black) as simple shapes.

Step 3 Transfer the shapes from the drawing onto the corresponding values of gray paper using the graphite transfer method.

Step 4 Cut and/or rip out the basic shapes and glue them into the proper positions.

Does seeing the subject in such simple terms inspire you to think differently about your own work? —A. R., inspired by an assignment from artist/instructor Siobhan McClure

Graphite transfer method:

Place a piece of graphite transfer paper in between the sketch and the support to which you are transferring the line. Retrace the sketch using a generous amount of pressure to impress the graphite onto the support. (This can also be done by shading the entire back of the sketch with graphite from a soft pencil [HB or softer]). Place the sketch over the support and retrace the sketch, thereby transferring the graphite to the support.

Here's what you'll need:
- Canson® paper (black, dark gray, light gray, medium gray, and white)
- White drawing paper
- Pencils
- Scissors
- Small straight-edged knife
- Archival glue stick

#91 **Never Say Never!**

Think of a subject or subjects you would *never* paint or sketch or a medium you would never use and DO it! —L. K.

#92 **Cross Contour**

Draw five objects using lines that cross over the planes of the object, defining the form without drawing its outer contours. Try tight drawings and loose drawings, and vary your line weight for added visual interest. This is a perceptual challenge! —A. R.

#93 **Art Class**

Ask an art instructor at your local college or university if you can observe one of his or her classes. As you observe, be a good student and jot down notes. What challenged you? What inspired you? What new technique(s) did you learn? —L. K.

58

#94 Natural History Museum

Where else but your local natural history museum are you going to see a cougar about to pounce on prey in suspended animation? Take yourself on a sketching trip. Museums of science and natural history are rich with objects to observe and draw from. They offer displays of animals, bones, landscapes, and early humans. Visit one and spend some time exploring various media. Bring a small collapsible stool and don't forget your travel watercolor set! —A. R.

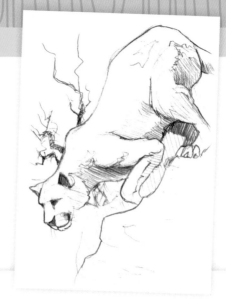

#95 Visual Regression

Tap into your past self to create a work of art based on something that has always captivated you. Perhaps it's a social issue, religious quandary, or something as mundane as a vase full of flowers. Think about how you would have visually interpreted your subject when you were five years old. Then think about the type of imagery, symbolism, and style you would've used when you were twelve and twenty years old. How would you depict that same subject now? After you've pondered the ways you would have viewed the subject at different stages in your life, combine those perspectives and approaches to representation into a single piece of artwork. This could easily be a drawing, painting, sculpture, photography, or mixed media project. —A. R.

#96 Mystery in the Moment

Put on a blindfold and allow yourself to create in the moment. Beginners should use a medium that isn't messy to clean up, such as molding clay. More advanced artists: Try using acrylic paints to discover how a lack of visual perception affects your ability to make art. —L. K.

#97 Symbolic Depiction

Is there an historical figure you find truly inspiring or fascinating? If so, ask yourself what it is about this person you find so alluring, be it for good or ill. Write a list. Then start compiling visual information (e.g. representative symbols) about the aspects of your subject's life achievements or personality. What types of visual information describe his or her place, culture, and time in history? Work on creating an abstract portrait of that person. A photo reference isn't necessary, as a lot can be said about people based on the types of symbols, patterns, shapes, colors, and line qualities chosen to represent them. However, working in an actual representation can add visual interest, as long as the formal elements are telling the majority of the story. Visually explain to the viewer why you find the subject interesting. —A. R.

▶ Student work by: Scoops, *John Wilkes Booth*, 15"x11", Acrylic on illustration board, 2010

Billie Holiday, acrylic on paper, 13½" x 6¾", 2005

#98 Exquisite Corpse

This is a game invented and played by the Dada and Surrealist artists of the early twentieth century. It's a fun, collaborative drawing exercise that can be done on site or through the mail. A minimum of two players is required; a maximum of four works best.

Step 1 Take one piece of paper and fold it in half. Then, fold the two halves in half to create an accordion-like fold.

Step 2 The first player draws the head of the creature. The creature can be human, animal, or monster. Allow the lines of the "neck" to touch the very edge of the fold so the next player can see them.

Step 3 When the first drawing is complete, conceal it by folding it over. Then, let the second player draw the arms and upper body without seeing the previously drawn head.

Step 4 After concealing the arms and upper body section, the third player (or the first player on the second turn) draws the pelvis to the knees. The fourth player draws the knees to the "feet." Unfolding the paper will reveal a complete rendering of a nonsensical creature. This can also be done in collage (see example at right).

—A. R.

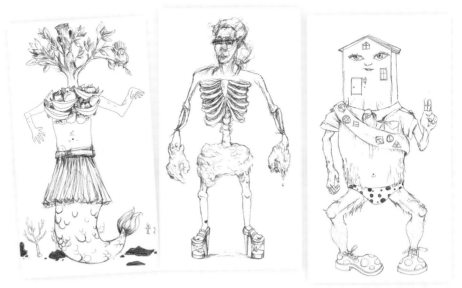

▲ Played by Nathan Rohlander, Jana Rumberger, Gedimin Bulat, and Amy Runyen.

#99 Art Is

Entrepreneur, author, and public speaker Seth Godin said, "Art is what we call…the thing an artist does. It's not the medium or the oil or the price or whether it hangs on a wall or you eat it. What matters, what makes it art, is that the person who made it overcame the resistance, ignored the voice of doubt and made something worth making. Something risky. Something human. Art is not in the eye of the beholder. It's in the soul of the artist." Think about how you can imbue the fearless soul of the artist into other activities that don't hinge on creativity and how that may make you a freer, more confident individual. —L. K.

#100 Out of Focus

Take a slide and project it, making the picture purposely unfocused. Allow yourself five minutes to capture the image in watercolor. Next, focus the picture correctly, and use a permanent fine-tip marker to add detail to your image. You have fifteen minutes.

—L. K.

Here's what you'll need:
- Slide projector
- At least one 35mm slide
- Watercolors
- White art paper
- Fine-tip permanent marker

#101 In the Buff

Whether the beautiful and voluptuous curves of a woman or the chiseled musculature of a man, the human form has captivated artists since the beginning of time. It's been the subject of millions of original works of art across the continents—from bronze statues to pencil sketches to oil paintings. You've probably sketched and painted the human form in many an art class and yet…have you ever painted in the nude? This assignment challenges you to explore another side of your creative self. Relax, go with it, and remember to close the blinds! —L. K.

GAMES

#102 Chimera

What would it look like if a pig and a fish mated? What would happen if you combined a bull and a tiger, or a snake and a horse? How about a dinosaur and a bunny? Have some fun sketching these and any other ridiculous mash-ups of disparate animals. —A. R.

ASSIGNMENTS

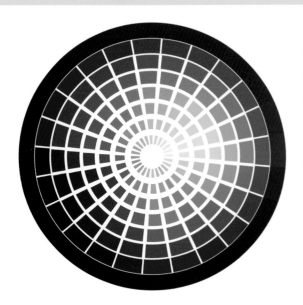

#103 Opposites Attract

What are your go-to colors? Find them on the color wheel, and then find the color opposite one of your colors. Substitute the opposites and see what mood you create. Can an apple still look like an apple if it isn't red, green, or yellow? —L. K., inspired by scrapbooking enthusiast Carolyn Miller

#104 Still Life

When you're in a drought for ideas, going back to the basics is a great way to get the creativity raining again. Set up a still life of objects you find visually appealing. It can be one simple object or a group of objects whose proximity in your still life gives them meaning beyond what they possess individually. What theme arises? Think about the type of mood you want to convey with your chosen objects. Will it be dark and brooding or fun and lively? Nostalgic and sentimental or humorous and irreverent? Next, consider its arrangement and your approach to balancing the shapes, values, colors, and textures. The type of lighting you use (direct, bright, dark, ambient, dappled) and the direction from which it comes adds another layer of meaning. Each approach to lighting has a different "voice." Now, ponder the background. Will the still life be set against a luxurious fabric or will it sit on the floor in a corner of a stark room? Will you view it from a distance, a moderate distance, or so close that the picture plane crops objects? Where will you designate eye level? There are so many things to consider when setting up a seemingly "simple" still life. If you arrange them with care, still lifes can tell an abundance of stories. —A. R.

Artists to investigate:
- Wayne Thiebaud
- Dutch vanitas artists
- Giorgio Morandi
- Jean-Baptiste Simeon Chardin
- Audrey Flack
- Janet Fish
- Claudio Bravo
- Vincent van Gogh

Photo © Tommy Martinez

#105 **Tommy Martinez**

Biography: I am of Puerto Rican descent, so emotions are a huge part of me, and I put them into everything I create. I grew up doodling, drawing, painting, and building things. After serving in the Marine Corps, I completed an Associate of Arts Degree in Graphic Design. Art is in my blood, a part of my soul. I've embraced it as who I am and will continue to enjoy every part of the creative process as it plays out in my life.

Q: Where do you find inspiration for your artwork?

A: I'm very visual and a free thinker, so anything I see or hear can bring inspiration. Inspiration is all around me—especially if I'm around other creative people.

Q: What do you do when you get artist's block?

A: Yikes! To me artist's block is about a feeling, being in a mood, in a mindset, but not always in the right mindset. When I get it, I challenge myself to keep trying something new and keep generating creative thoughts. I'll doodle or paint random things or I'll look at images and go through my old sketchbooks to see if something sparks a feeling or thought.

Q: How do you challenge yourself in the studio and avoid repetition?

A: I'm very hyper and my mind is always going and trying different things so I don't get bored. I create with mood and emotion, so every day is different. If I'm not in the mood to paint or draw, I might be in the mindset to build a frame for one of my paintings, I might be sculpting with clay, or doing anything that keeps my mind going and hands moving. It's very hard for me to stay stuck in repetition. There's too much creative energy out there.

Q: What advice would you give to a blocked artist?

A: My Rx for artist's block is to try anything that keeps your mind active, but then again, just relaxing and or daydreaming can be healthy, too. Keep an active and open mind. Let it be free.

Q: What artist/s or designer/s do you admire for their creativity?

A: Having no formal art training besides an art class here and there, most of my art has been self-taught by reading books and enjoying other artists' work like Dali, van Gogh, and Picasso. When I shared studio space in Bridgeport,

Connecticut, Allen Wittert was very influential to me.

Q: How do you balance your creative impulses with making work that consumers will buy?

A: I try and enjoy everything I do. It may be creating something that appeals to consumers and helps pay my bills or something that I create from my mind just for myself to hang in my home. I enjoy creating. If I don't enjoy doing it then I just don't do it.

Q: Can you remember a class or an assignment from art school that challenged your creativity and possibly helped to redefine your aesthetic or thinking? If so, what was it?

A: Life drawing took me out of thinking that [art] had to be perfect from the start. Throughout the course we drew someone posing for ten to fifteen seconds. By the end of the course we could see how much our drawings had changed. [You could notice the progression of us] stressing about it being perfect in the beginning to having fun drawing it sketchy and enjoying the process of going back and perfecting it. That redefined my way of thinking and I apply it to all of my creative work and art. —L. K.

Woman's Blossom, oil on canvas

Artworks © Tommy Martinez

Rainy Sunday, mixed media

#106 Inspiration Connection

Peruse online art galleries, blogs, and web sites that show images of historical and contemporary artworks. Read thought-provoking articles, watch video clips, and find out what's going on at locations near you. Brick-and-mortar art museums and galleries also have web sites featuring a wealth of images from their art collections. Bookmark and refer to them when facing a block, or make visiting these sites part of a daily ritual to keep your head in the game! —A. R.

Give these web sites a try:
Artcylopedia: www.artcyclopedia.com
Artnet: www.artnet.com
Artslant: www.artslant.com
Boooooooom: www.boooooooom.com
Daily Serving: http://dailyserving.com
Deviant Art: www.deviantart.com
Google Art Project: www.googleartproject.com
Hi-Fructose: www.hifructose.com
I Heart Photograph: www.iheartphotograph.com
The Metropolitan Museum of Art: www.metmuseum.org
New American Paintings Blog:
http://newamericanpaintings.wordpress.com
PBS' Art21: www.pbs.org/art21

MENTAL EXERCISES

#107 Valuable Values

What are your core values? What principles do you hold dear? Perhaps you feel strongly about family or freedom of expression, or hard work and honesty? Conversely, what values that other people prize (like extreme nationalism and racism) do you find repellent? If you find yourself frequently discussing a particular issue, maybe it's time to start making some artwork about it. Begin by sketching out symbols that represent the topic and your feelings about it. Think about abstract shapes and colors that reinforce your ideas. What colors, shapes, and patterns convey the concept of civil liberties or sexism? Compile reference material that supports your topic and get in the studio! —A. R.

◄ Stylistic devices in this traditional Chinese wall painting could be used in artwork to create a direct connection to cultural heritage.

#108 Do it Now!

First, set up a small canvas, about 12" x 12." Then set a cooking timer for fifteen minutes and see how much of a painting you can get done. Do about six canvases. —L. K., inspired by artist David Fairrington

#109 Connections

Sometimes new ideas are born when you consider two unlikely subjects in the same context. See what happens when you try to make conceptual and visual connections between a dog and a covered wagon—or a policeman and a refrigerator. Create a list of several unlikely partnerships and outline the similarities between each pairing. The objective is to understand how connecting wildly differing subjects can help you link seemingly differing ideas that you want to create artwork around. —A. R.

#110 Inspiration is...

"Inspiration is that magical moment that captures a spark of imagination, the glimpse of something new and unique. That moment when there is a new awareness of something that brings passion and energy to explore and create. A moment in time . . . a new awakening . . . a remembrance. An exceptional experience alone or with a companion. A vision . . . a view . . . a feeling, day or night, awake or sleeping. The sky, a cloud, a shadow, reflection, light. The spark and energy is kindled and the imagination draws you further into a creative world. I will be inspired by light and I will try to express all its qualities, its source, its energy." —Contributed by Robert Merchant, award-winning designer in the hospitality industry and faculty member, Art Center College of Design, Pasadena, California. —L. K.

#111 Gesso Transfer

There are many ways to transfer printed materials to various supports, however a gesso transfer creates a flat, matte surface that can be painted over or drawn back into with ease.

Here's what you'll need:
- Color or black-and-white images from magazines, newspapers, or printed from a laser printer (inkjet printers do not work well)
- Gesso
- Paintbrush
- Heavy paper
- Canvas or panel for support

Step 1 Obtain an image you'd like to transfer from one of the sources mentioned in the materials list. Crop it to the specific area you want transferred.

Step 2 Paint a thin layer of gesso onto your support in the area where you'll be applying the image. Then, paint a thin layer of gesso directly onto the surface of the image.

Step 3 While both surfaces are still wet, lay the image onto the paper. Use a brayer or your hands to smooth out the paper starting from the inside working out. As you do this, make sure there are no bubbles and that an even, flat attachment has occurred.

Step 4 Allow it to dry thoroughly. Overnight is best.

Step 5 When completely dry, spray or dabble water over the back of the paper and gently rub with your fingers. Little balls of paper will start to come up and entire sections may peel off with ease. After removing all the paper, allow it to dry. If there is a slight film left over from the paper, repeat the process.

Step 6 Now you can further manipulate the image in any way you like! —A. R.

#112 **E-Fast**

Scientific studies on creativity and innovation have yielded amazing insights when respondents were asked to abstain from using any type of technology for a sustained period of time. For a twenty-four-hour period, turn off your computer, phone, television, radio (at home and in the car), MP3 player, e-reader…you get the idea. Pay attention to what thoughts and feelings surface during and after your E-Fast. Did any creative ideas come to mind? How might they influence your art? For an added challenge lengthen this experiment to two days, until you can work yourself up to an entire week. For the steadfast few who are sincerely enjoying the benefits of an E-Fast, challenge yourself to a month! —L. K.

EXPERIMENTS IN MEDIA

#113 **Wire Sketches**

Draw through space! Create a sculpture of a human or animal using only wire, as though it is a three-dimensional gesture drawing. First, "draw" the basic contour of the form, looking at the large overall shapes. Then wrap the wire around the initial form to build up the volume. You can make the form as dense or as open as you'd like. Consider the speed at which the wire lines travel through space, making quick or slow turns. Try creating one that is angular, using straight lines and sharp angles, and another that is curvilinear using organic, undulating lines.

—A. R.

Tip:
20-gauge wire can be purchased from an art store. Alternatively, go to a hardware store and get a lot more of it for a lesser price.

#114 Visual Investigation

In order to truly understand something from a visual perspective, you must investigate it thoroughly. Examine it, hold it, feel its texture, smell it, and of course, draw it! Choose an object that is not too simple and not too complex. A tool, utensil, or natural object like a seedpod works well. Draw it at least thirty different times from all possible angles. Cut it or break it open and draw or

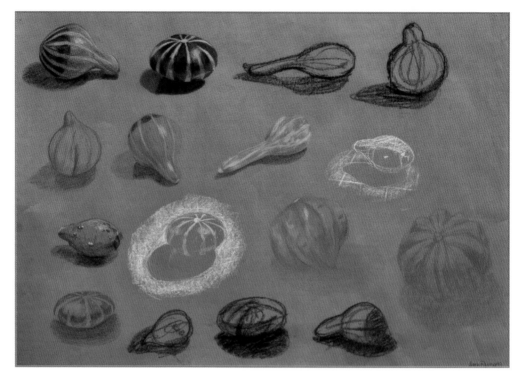

paint its insides. Try different lighting scenarios—direct light, bright ambient light, dark light, dappled light, etc. Also use a variety of media, such as ink, pastel, graphite, or watercolor. You could even create a clay or wire sculpture of it. Observe it from a purely structural point of view (how is it built?), and then investigate its surface texture. Finally, do gesture drawings and fully rendered value drawings of it. —A. R.

I drew several different types of squash for this investigation.

#115 Did You Know?

Laughter decreases from 113 chuckles a day as a child to 11 har-de-hars a day as an adult. Lighten up, laugh, and enjoy the fun of creating!

—L. K.

#116 Do it Now!

There are some truly moving and inspiring phrases in songs, such as the line, "the sky is the color of love." Paint that sky. —L. K.,

inspired by artist David Fairrington

MENTAL EXERCISES

#117 Analyze It

Analyze an image of a piece of traditional fine artwork and observe how your eye moves around the composition. Which formal elements draw the most attention by conveying an emotion and delivering the message? Go beyond the work's subject matter and figure out its formal meaning. Is the piece about color, value contrast, patterns and textures, or shape? Perhaps it's based on line, space, or a combination of many. Assess the type of compositional structure used, and consider how the artist used abstract formal elements to relate their conceptual message. How can choosing formal elements that reinforce your concept propel your visual messages further? Take a few pointers from the pros…

A few artworks to consider:

Vincent van Gogh, *The Night Café,* oil on canvas, 1888

Van Gogh wanted to convey the dreariness and sickness abundant in this all-night café that people of ill repute frequented. He uses contrasting colors of red and green with large amounts of yellow—all at nearly pure hue—to effectively paint a very uncomfortable scene. The broken concentric rings that envelope the lamps indicate that even they glow with weariness.

Caravaggio, *Narcissus,* oil on canvas, 1597–1599

In order to convey the endless love that Narcissus had for himself, Caravaggio chose a clever yet simple circular compositional structure. Narcissus gazes at his reflection as it locks itself with his arms. No other design elements disrupt this self-admiration.

Henri Matisse, *The Joy of Life,* 1905–1906

The thematic goal of this image is people living in peace and harmony with one another and with nature. Matisse achieved his image of utopia using gentle, undulating lines, soft shapes, and a bright polychromatic color harmony.

Ernst Kirchner, *Street, Dresden,* oil on canvas, 1908

Using heavy black as a background, Kirchner painted zombie-like people in high key color. Crudely painted shapes and muddled faces with holes for eyes reflect the alienation and angst of a man living in a populated city, but feeling isolated. —A. R.

#118 Hand-Pulled Linocut Print

Linocut is a form of relief printmaking in which you carve a design into a piece of linoleum, and ink or print it onto paper as many times as you wish. —A. R.

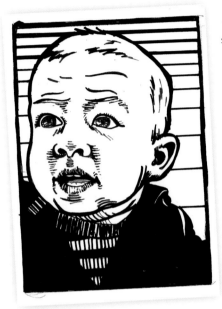

◄ **Step 1** Start with a sketch. For this example, the sketch and lino block are 5" x 7". Now flip your image. When it's printed, it will be the reverse orientation to what you have carved on your plate. Use a permanent marker to fill in all the shapes that will be printed in black. Imagine how these shapes will connect after you carve the areas intended to be the white of the paper.

Here's what you'll need:
- Mounted or un-mounted linoleum block
- Printing ink (water soluble works nicely)
- Gouge tool and various gouges (#1 V-shaped and #3 and #5 U-shaped)
- Brayer
- Heavy rag paper or Japanese rice paper
- Wooden spoon
- Palette
- Graphite transfer paper (optional)

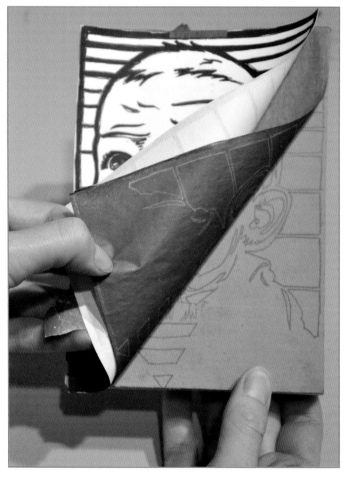

Step 2 Next, transfer the drawing to the lino block using graphite transfer paper. For clarity when carving, you may want to fill in the shapes that will be left uncut for inking with pencil or marker.

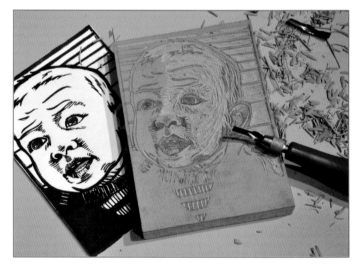

Step 3 Now begin carving around the large shapes and details with your small (#1 V-shaped) or medium (#3 U-shaped) gouges. Then carve out the large center portions of the shapes with a large #5 U-shaped gouge.

Caution: Make sure that the hand you're supporting the block with is out of the path of the gouge tool!

Step 4 Tear down several pieces of paper to the correct size. Making prints is a trial and error process. You may need to pull several to get a perfect one.

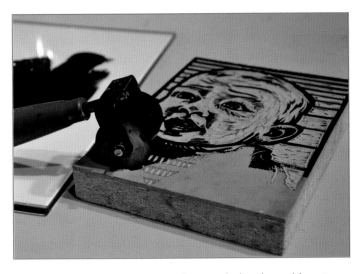

Step 5 When the carving is complete, wash the plate with water, removing stray linoleum debris. Squeeze ink onto your palette and roll your brayer through it in a forward-only motion. Avoid goopy ink on the brayer. When inking the plate, move the brayer back and forth in all different directions. Inspect the plate for any areas that may need more carving.

Step 6 Lay the paper on your work surface. Place the inked plate face down onto the paper. When placing it, make sure there is an even border around the top and sides with a little bit more room at the bottom to sign your name. Next, carefully turn the plate and paper over and place the plate on its back. Use the back of a wooden spoon to burnish the paper. Rub in small circles in all directions with a generous amount of pressure. Make sure you cover the entire plate!

Step 7 Finally, gently peel the paper off the plate and set it aside to dry. Once dry, add the edition of each print, title, signature and date in graphite directly beneath the print.

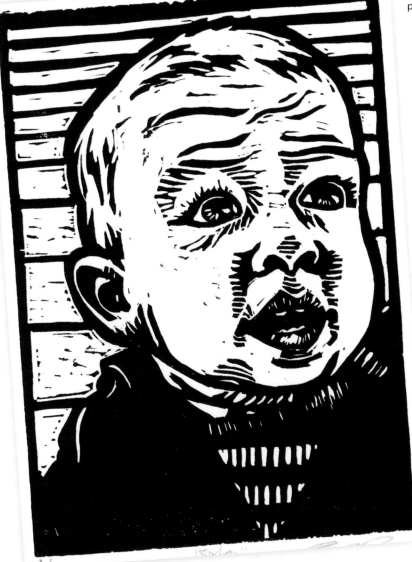

Sixten, 2011

#119 Assemblage

Found objects can be meaningful surfaces on which to work. They carry with them all of the associations attributed to the functions they perform. These associations can then be used and modified by the artist by altering the object in various ways.

Begin by finding objects you consider significant and put them together in an engaging way. Try to make the sum of the parts more interesting than the individual elements, paying careful attention to the elements of design and good craftsmanship. Also consider the original meaning of the objects, as well as how that meaning changes after you alter them. Will they still be recognizable when you're finished? What is the combined meaning of one object juxtaposed to another? For example, a baby bottle glued to a car engine. What would that say? Next, paint, collage, or remodel the surface with clay, or leave it as is. Never limit yourself in media or found materials.

Paul Leach used to take daily walks into the countryside from his home in Bishop, California. Along the way he'd collect interesting objects, return home, and assemble them into wreaths or shadow boxes with implied narratives. By emasculating the menacing radii of empty shotgun shells and bullets with marbles, baby pinecones, and shells, he effectively shifts the power from human to fawn. —A. R.

Untitled, mixed media, 18" diameter, 1985

Artists to investigate:
- Joseph Cornell
- Robert Rauschenberg
- Betye Saar
- Louise Nevelson
- Whitfield Lovell
- Edward Keinholz

#120 Another Person's Treasure

Take a trip to your local thrift store and look around. Does any one object catch your eye, in spite of not knowing what on earth you'd do with it? If so, buy it and make a painting on it. It could be something simple like a vase, or it could be an appliance or an old pair of shoes. Think about the kinds of images the object brings to mind. Then paint something directly onto its surface. If you found more than one object, how does placing the objects next to each other affect their meaning? What does it mean to place an old pot next to a worn pair of shoes, each with unique paintings? Find out for yourself…

These mixed media paintings are from a series I created about blue-collar workers. Each portrait is of a real person caught in a moment while performing his actual job. The portraits were painted directly onto the types of tools the subjects use to perform their tasks. —A. R.

Rico, 18" x 25½", acrylic and resin on baking sheet, 2005

Luis, 19" x 27", acrylic and resin on baking sheet, 2005

#121 Stare at the Toilet

A friend's client once required 3-D drawings for an innovative toilet he intended to patent. The drawings had to be completely accurate because they would ultimately sell investors on his concept. My friend was stumped as to how to render a unique and eye-catching curve. When confronting such blocks, she turns to a model to aid her drawing—otherwise her mind zooms throughout the 3-D world completely unfocused. In this case, she went to object in question—a full-size toilet—for inspiration. Remember that seeking new inspiration in an old standard can combat creative blocks and result in a fresh product. —L. K.

#122 Micro

Think small! Examine a tiny object in great detail. Draw it from every possible angle. Draw it up close as though it were huge; then create an abstract painting based on the simple shapes and textures only visible upon close examination. You'll quickly learn to appreciate the intricacy of small objects. —A. R.

#123 Toy Time

Organizational consultant Janine McDonald trains leaders to utilize their creativity in problem solving by instilling greater confidence within. One of her proven techniques integrates toys in the experiential learning process. Toys, she says, create a sense of play and childlike wonder and simultaneously help develop new skills sets. Begin reaping the benefits of play by raiding a child's closet for two popular items:

Play-Doh®: Engage your sense of touch and create something. Experiment by mixing a couple colors together, roll it, cut out shapes, bake it…the options are many!

Tinkertoys: Seeing these may induce a wave of nostalgia in folks of a certain age! You can play this game alone, but it's far more enjoyable in a group. Your task is to build a tall tower. Take twenty minutes to plan it. Then it's time for construction…and you only have forty seconds. (Shhh—keep this a secret from the others!) Most likely, you won't get very far with this time constraint. Now go back and allow yourself five minutes to plan, knowing you'll have forty seconds to build. You'll be amazed that you will successfully complete this challenge given such short time restraints! —L. K.

#124 Shelly Becker-Cornelius

Biography: Shelly Becker-Cornelius began her art career as an illustrator for *The Baltimore Sun's* Op Ed section while still in fine art school. Collage was her chosen medium, but she eventually migrated toward the television industry, working in art departments as lead set painter, set decorator, and prop maker on children's shows and commercials. She started her own faux-finishing and mural painting business, culminating in live performance painting for special events. She has served as art director and production designer for several Emmy® Award-winning network television shows and currently works with clients as an interior design and color consultant. She resides in Los Angeles, California.

Q: Where do you find inspiration for your artwork?
A: Shapes, patterns, and color combinations in nature capture my attention constantly. Hunting for quirky treasures at flea markets always gets me excited to get home and do something creative. Graphics and textures found on dilapidated billboards have also been a good source.

Q: What do you do when you get artist's block?
A: I just get away from the project and do something unrelated because it lets tension fade away and ideas float toward me. I usually go do something I've been procrastinating completing. By "avoiding" the artist's block, I am turning my attention toward something I "shouldn't" be spending precious time on, which makes it feel naughty or forbidden. By doing so, I feel better having finished icky tasks, and in the process I can return to the project with a fresh perspective.

Q: How do you challenge yourself in the studio and avoid repetition?
A: Luckily, I work in various mediums. Art direction is very different from doing a mural or a collage. Each new project has its own allure and difficulty, providing a fresh experience every time.

Q: What advice would you give to a blocked artist?
A: Try to relax in whatever form that takes and do something fun to loosen up. Sometimes "wasting time" on something banal can be quite beneficial. If it gives your right brain a brief holiday, it's worth it.

Q: What artist/s or designer/s do you admire for their creativity?
A: Matisse for shape relationships, van Gogh for expression in color, Joseph Cornell for his magical shadowbox worlds, and Kandinsky for spontaneity and emotional purity.

Q: How do you balance your creative impulses with making work that consumers will buy?
A: There has to be a little overlap to keep you interested. Successfully meeting the needs of a client is very rewarding and enjoyable, and being able to infuse your own sensibility somewhere in the process is better yet.

Q: Can you remember a class or an assignment from art school that challenged your creativity and possibly helped to redefine your aesthetic or thinking? If so, what was it?
A: Freshman year Life Drawing class instilled the importance of really seeing. The instructor demanded we spend at least twenty hours per week on our assignments, usually involving drawing ourselves as life models. Yes, we ran home to stand in front of mirrors, position lights, and drew! Each week we posted our pictures for the entire class to critique. We got over ourselves, so to speak, very quickly, mastered drawing the human form from the inside out, and most importantly learned to see. The experience has affected my work every day since. —L. K.

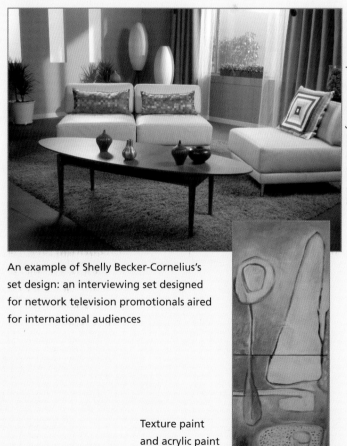

Artwork and photo © Shelly Becker-Cornelius

An example of Shelly Becker-Cornelius's set design: an interviewing set designed for network television promotionals aired for international audiences

Texture paint and acrylic paint on canvas

77

#125 **Night Lights**

Nothing is more universally appealing than watching glittering fireworks make art in the dark sky! "Oohs and aahs" ripple through the crowd at France's Bicentennial in the same manner giggles and gasps reverberate throughout the banks of the Three Rivers in Pittsburgh, Pennsylvania, during the annual Regatta. Think back to your most recent experience viewing a firework display. Perhaps it was after a baseball game, concert, or in celebration of a national holiday. What sounds do you hear: a symphonic overture, loud booms, or the sizzling sound of fireworks as they descend? Which colors and shapes excite you? For your next creation be inspired by the sights, sounds, and wonder of fireworks! —L. K.

#126 **Do it now!**

One of my favorite movies is *The Sound of Music* (1965) filmed in Salzburg, Austria. In one scene the lead character, Maria, sings about her favorite things. Pull out your sketchbook or scrap paper and start recalling some of your favorite things. Are there any surprises? Ask a friend what one of his or her favorite things is and do six paintings or drawings about them —L. K., inspired by David Fairrington

#127 Installation

Never be afraid to command the space. Create a sensory piece of artwork that goes beyond the second dimension and invades the space of the viewer. It can be as aggressive as a work that must be walked through while ducking, or simply two-dimensional works hung in such a way that they could never be recreated elsewhere. The subjects artists work with in installation art are just as wide and diverse as the concepts and content in the traditional fine arts. Installations are typically site-specific; the artist makes a work of art unique to a particular location and alters the viewer's experience of it. This type of work can be permanent or temporary, indoors or out. Try it for yourself. Transform your workspace using any materials you see fit. Take the work you're currently doing into the physical realm.

Nathan Huff's paintings and installations are personal excavations into his recollection of specific moments. He combines disparate objects whose physicality is familiar to the viewer with elegantly painted representational imagery. The result is a three-dimensional invitation to the viewer to peek inside a part of his history and relate to the humorous and surreal nature of memory. —A. R.

Artists to investigate:

- Kurt Schwitters
- Ann Hamilton
- Bill Viola
- Ai Weiwei
- Allora & Calzadilla
- Sarah Sze

Artworks © Nathan Huff

Rescaling, Gravity and More, mixed media installation, 2009

Restraint on Ice, mixed media installation, 2009

Gravity and More, mixed media installation, 2009

#128 Still Life Self-Portrait

An individual's personal items can't say a word, but they speak volumes about their owner regardless. We all have objects that are meaningful to us for either profound or mundane reasons. Gather some items you feel tell the story of you and arrange them in a still life. Include objects that reflect your history, family, hobbies, religion (if you have one), ethnicity, and general interests. Consider the placement of the objects. Should they be carefully arranged on a tabletop, or displayed haphazardly on the floor? Will they sit on a gorgeous silk fabric or on a piece of burlap? Everything included in this piece offers the viewer insight into your personality, so choose wisely. Paint or draw this self-portrait. —A. R.

Artist to investigate:
–Audrey Flack

#129 Everything Will Flow

Entrepreneur Susan Petrella's new business venture has to do with "all things creative!" When she feels mentally or creatively blocked, she does something she loves: baking, gardening, playing the piano, visiting an art exhibit, or cooking. Susan recommends keeping your challenge in mind as you're out playing and enjoying life. That way, the challenge remains in your subconscious while the leisure pursuits distract you from stress and other blocks that cloud your view. You'll be surprised when one idea after the other comes to you.

Hungarian psychology professor Mihaly Csikszentmihalyi, author of *Flow: The Psychology of Optimal Experience,* teaches that to be inspired and creative is to really be "in the flow." For Susan, "flow" isn't linear—it's circular! —L. K.

#130 Reapplications

Try using traditional media in an unexpected way. If you're used to making drawings with the pointy end of a charcoal stick, experiment with turning it on its side and doing a whole drawing with long, thick strokes. Make a painting using only a palette knife instead of a brush. Finish off a clay sculpture with an old bristle paintbrush rather than smoothing the clay with your fingers. Push yourself to think beyond an art tool's intended use and reapply it to any subject matter you're working with. —A. R.

This painting was created using only a palette knife to apply the paint. This technique also can be used to make representational paintings.

#131 Muse from the Movies

Consider one of your favorite films or a group of films. Ask yourself what you like about this film or films— the breathtaking imagery and cinematography or the tone of its story line? Study the film or films' color palette and overall tone. What is the underlying theme? By analyzing why you like a particular film or genre, an unrealized direction you should be heading in the studio may spring to mind. So go ahead and spend some hard earned studio time watching a movie. Take some notes, make some sketches, and find out what really elicits an emotional response in you! —A. R.

#132 Do it Now!

Sit down, get out all of your art books, and re-read them. —L. K.

#133 **Copycat**

Attempt to copy an artwork you love. It needn't be an exact duplicate; we're not looking to fool the Louvre here. Analyze how the artist used value, shape, color, and mark making. Research the artist's materials and techniques. Copy a great work of art not only because you're parched for ideas, but because doing so reawakens part of your brain and helps you see things differently.

Many museums restrict you from setting up shop and painting directly in front of an image; however, no-flash photography and sketching with dry media are both almost always allowed. Find out what the policy is about copying on site at your local art museum or use an image from the Internet or a book for reference. Copying is not limited to painting; copy a sculpture if you're a sculptor.

<div style="writing-mode: vertical-rl">Artworks © Lala Ragimov</div>

Copy of Scorn from Four Allegories of Love by Paolo Veronese, 1575

Moscow-born artist Lala Ragimov is dedicated to researching and employing the materials, techniques, and ideals of Flemish Baroque and Venetian Renaissance painters in her own work. Through a regular practice of creating careful copies of master works, she broadens her knowledge and skill, thereby strengthening her own fine artwork and illustrations, and for a while transports herself into the world of the artist she chose to copy. —A. R.

◀ Copy of *Still Life with a Glass and Oysters* by Jan Davidsz de Heem, c. 1640

▶ Copy of *The Maid of Honor to the Infanta Isabella* by Peter Paul Rubens, c. 1620s

#134 Did You Know?

Illustrator and author Edward Gorey, noted for his fanciful representations of all things macabre, was an ardent balletomane. From 1957 to 1982, the George Balanchine devotee attended every performance of the New York City Ballet.

ASSIGNMENTS

#135 Mechanical Botanical

Take a field trip outdoors to collect leaves, twigs, seedpods—anything botanical. On your journey, also gather some objects that are "mechanical" or human-made. These can be tools, eyeglasses, utensils, or anything that appears manufactured. Find objects with a flat surface on one side for easy tracing. When you have a good amount of objects, begin composing them on a tabletop. Balance the shapes against one another. As soon as you have what you believe is a pleasing composition, transfer it to a drawing surface like paper or illustration board, and trace the objects with a pencil. An abstract collection of shapes will soon result. Some will be compound shapes and others will be independent, recognizable shapes. You can then use this drawing to create a painting or a more detailed drawing.

—A. R.

#136 Do it Now!

Set a timer to go off every twenty minutes. When it sounds, take a break and move your entire body for twenty seconds!

—L. K.

#137
Shift Gears

Professional artist Mary Beth Volpini likes to work with color and movement to unblock her creativity and believes you'll benefit from one of her favorite exercises. First, pick out a few colors of paint (she prefers acrylic). Then, begin painting and moving at random to shift from your left brain to your right brain. Now, choose a few colors and start moving as you follow these instructions:

—L. K.

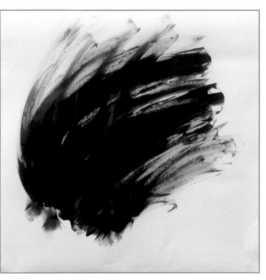

Paint the worst part of your day.

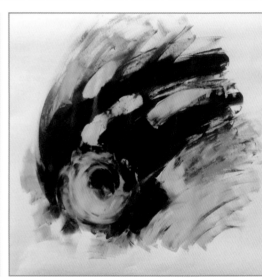

Paint the best part of your day.

Paint how you feel right now.

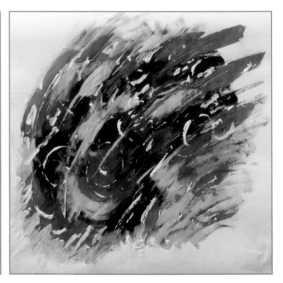

Paint your hope for tomorrow.

Artwork and photos © Mary Beth Volpini

#138 Hard Edges

Force your mind to see solid, flat shapes on a surface that has none. —A. R.

Step 1 First, choose a representational subject with smooth color and value transitions, like a human figure, flowers, or fabric. Create a painting using only hard-edged shapes.

Step 2 Break down what you see into a value map drawing by sketching a contour line around every shape created by a color or value change on the surface.

Step 3 Now transfer the drawing onto a smoothly finished support, like a panel, illustration board, or heavy paper, and then paint it with acrylic paint. Always paint the shapes in the back first, working forward. Try using a masking technique if you have trouble with a shaky hand.

#139 Tapping into Creativity

For the past fifteen years, internationally recognized, Guild Certified Feldenkrais^CM Practitioner Darcia Dexter has helped artists move through physical blocks in order to tap into unlimited creativity and reach their full potential. Try this exercise to unlock your untapped creativity:

Stand comfortably with your knees slightly bent, your arms at your sides, and your head and eyes on the horizon. Focus on your stance for a moment and then gently raise your heels about 1/2" to 1" off the floor, and then tap them on the floor. Begin to tap in double beats with a slight pause emulating that of a heartbeat. Stop to assess the quality of your stance again. Try to feel your skeleton supporting you, which helps release lingering muscle tension and gets creative juices flowing. Always remember to move within your comfort zone. —L. K.

#140 Mind's Eye

Analyze a complex object. Really look at it. Ask yourself questions about it: How tall is it versus how wide it is? What is its surface texture? What details are there? Where are the curvilinear shapes and the rectilinear shapes? Spend several minutes sizing it up. Then draw the object without looking at it. Recall as much detail as you can. Don't stop drawing until you can't remember another single thing to add. Compare your drawing to the actual object. —A. R.

#141
Information Trawl

Even if you're a voracious consumer of information, you may find it surprising that when you examine the kinds of information you consume, it's all about the same types of things. We all have our go-to websites, magazines, and books we like to peruse, but let's try stepping out of the comfort zone. Buy a magazine that you normally wouldn't and read it from cover to cover. Check out a magazine about tattoos if home décor is your thing. If you've never cracked open a *National Geographic,* perhaps now is the time. Listen to a Latin radio station if you're always tuned into classical. Exploring new websites, periodicals, books, and music you otherwise wouldn't allows you to experience new information and get the mental gears turning. —A. R.

#142 **Domestic Bliss**

There is inspiration all around you; all you need to do is stop and consider it. Is there anything about a day out shopping with the kids, cleaning out the garage, or making breakfast that could inspire a work of art? Think about how often we take for granted the simple things around us—the daily activities that keep life going. Perhaps you could build an excellent body of work on your roommate, spouse, or children. Maybe visually recording the lives of your pets or your flourishing or floundering deck plants could be fodder for a collection of photographs or paintings. Allow your mind to stop and linger for a moment, pondering the extraordinary within the ordinary.

Anne-Elizabeth Sobieski's lushly painted images depict subjects of transient beauty encountered in her daily life. Her family, friends, pets, and quiet scenes from her household provide intimate yet universal content. Each painting is an attempt to hold onto fleeting moments and to thwart the inevitable loss resulting from the passage of time. —A. R.

Where There's Smoke, oil on linen, 36" x 24", 2010

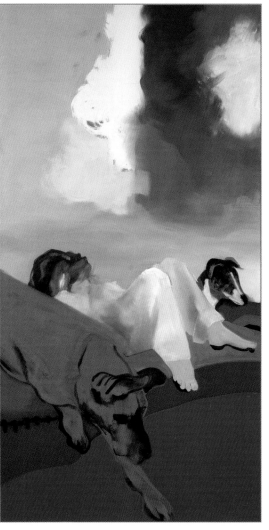

13, oil on linen, 36" x 24", 2011

The Sentinels, oil on linen, 70" x 36", 2010

87

#143 Gel Medium Transfer

You can transfer images from printed materials onto a canvas, panel, or another piece of paper using acrylic gel medium. (It's better if it's gel, not matte medium.) The fact that gel medium is clear allows for great versatility. For this example, I painted some color onto the support first so that it would show through the black-and-white print when complete. Color images transfer equally as well. —A. R.

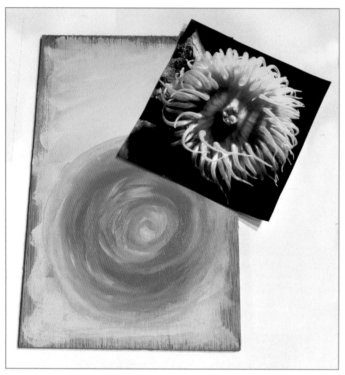

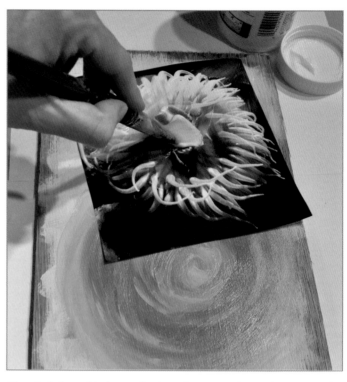

Step 1 Obtain the image you want to transfer. If printing at home, you must use a laser printer to print it. Inkjet copies don't work well for this project. You can also use wrapping paper or images from magazines. Remember that, once transferred, the image will be the reverse of the original. This is particularly important if transferring text.

Step 2 Paint a thin layer of gel medium onto the surface on which you intend to transfer the image. Then paint another thin layer onto the surface of the image to be transferred.

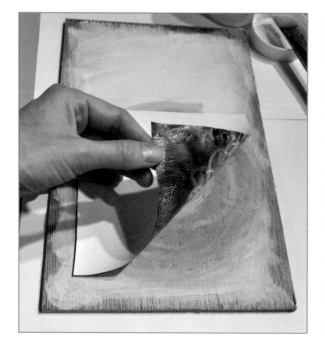

Step 3 Place the image to the surface and apply pressure to the center, smoothing out toward the edges. Be careful to get out all the air bubbles. Allow it to dry for several hours.

Step 4 After it's completely dry, apply small amounts of water to the back of the paper one section at a time. Gently rub the back of photocopy with your fingertips until the fibers begin to ball up and peel away. Don't be too aggressive with it or you may damage the image.

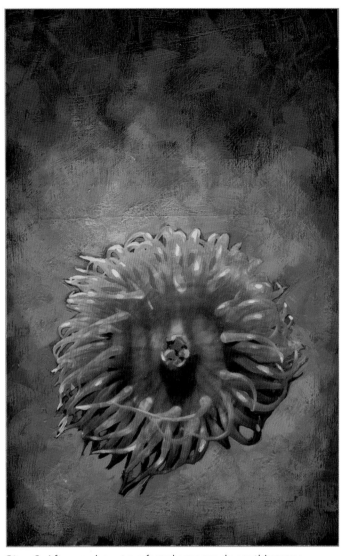

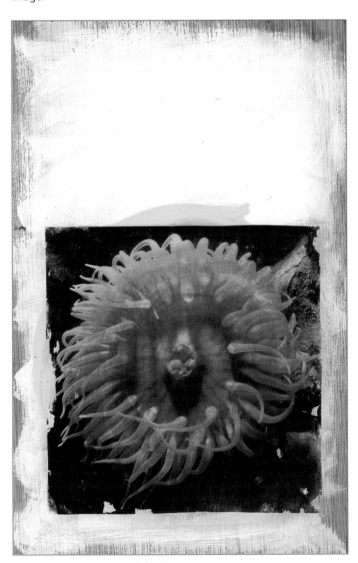

Step 6 After you have transferred, you can do anything you want with it. Leave it alone, or paint on or around it.

Step 5 Continue until all the fibers are gone.

#144 **Day of the Dead**

Each year on the 1st and 2nd of November, Mexicans celebrate the Day of the Dead or *Día de los Muertos*. It's a time for friends and family to unite in remembrance of loved ones who have died. Private altars are set up and adorned with marigolds, skulls, and the deceased's favorite beverages and food. Similar graveside observances are also held in Brazil and Spain. Some Asian, African cultures, and European cultures remember the dead with grand celebrations and parades. Dying is many people's number-one fear and yet there is an odd fascination with the macabre. What are your views on death? Reflect on how they factor into your creative work. —L. K.

Photo © Linda Krall

#145 **Hand-y Work**

The introductory exercise at my first International Forum of Visual Practitioners conference required attendees to closely observe our hands. Sure, I could do that—but for ten minutes? What was the point? I quickly came to understand why; several surprising thoughts and feelings came to me. First came the realization that I'd never taken the time to really look at my hands except for a quick glance after a manicure. Second, I noticed that my hands weren't young anymore. There were crevices, sunspots, and early signs of arthritis in the joints. Finally, I felt a deep appreciation for my hands and all that they enable me to do: type, massage, carry, twist, hold, gesture, wipe, strum a guitar, etc. Most of all I realized how important they are to my work of strategic illustrating. Take some time to study your hands and see what surprising new insights come to you.

—L. K.

#146 **The 360**

Analyze a fictitious crime scene where a murder took place from various points of view. It's perfectly fine to make it up on the spot. How would the murderer, the victim, a witness, the investigator, the cleanup crew, and the public perceive the scene? Write a paragraph from the perspective of each. —A. R.

INSPIRATION

#147 **Imagine!**

Lauded for his theory of relativity and considered to be the greatest scientist of the twentieth century, Albert Einstein said, "Imagination is more important than knowledge. For knowledge is limited to all we know and understand, while imagination embraces the entire world, and all there ever will be to know and understand." Take this opportunity to approach at least one creative project without allowing should-dos to override what you *could* do.

Here are a few other of my favorite Einstein quotes:

—L. K.

> "It is the supreme art of the teacher to awaken joy in creative expression and knowledge."

> "True art is characterized by an irresistible urge in the creative artist."

> "The monotony and solitude of a quiet life stimulates the creative mind."

GAMES

#148 **Read Between the Lines**

Remember being overjoyed as a kid to receive a Dot-to-Dot coloring book? Typically there was a theme: Walt Disney characters, comic book heroes, or a seasonal one for a holiday. For this exercise inspired by strategy, insight, and innovation expert Sandie Glass, take out a piece of paper and arbitrarily add dots to the page. When you feel you have enough dots, draw lines between various dots to create an abstract image. Some suggestions are: flower, face, cat, tree, fruit, bicycle, and person. —L. K.

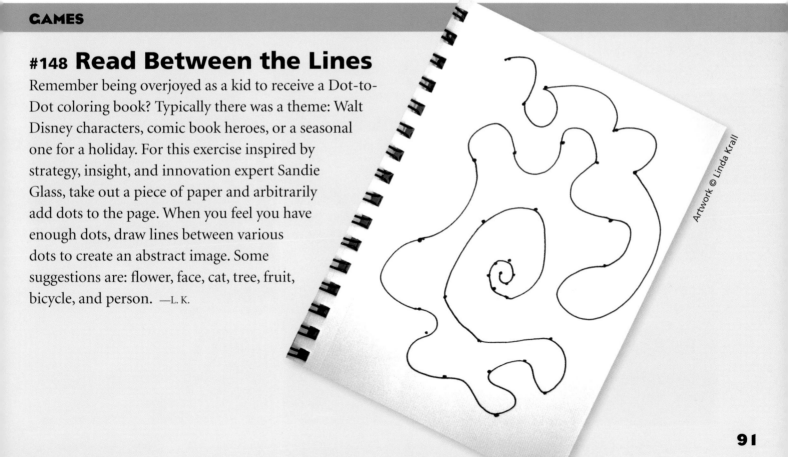

Artwork © Linda Krall

#149 En Plein Air

Go outside! Painting *en plein air* (in the open air/out of doors) began in France in the mid-1800s. With the 1841 invention of portable paint tubes, artists, including Impressionists and those associated with the Barbizon School, could finally paint landscapes from direct observation. The experience of painting landscapes from life far surpasses using a photographic reference. The colors and subtle value shifts are simply not as well defined in photographs.

Take a hike or just go into your backyard and create a painting on the spot. If you don't finish your painting before the light changes dramatically, pack it up and continue a different day at the same time. Use watercolor, acrylic, oil, or pastels. Paint a land or cityscape abstractly or representationally. Either way, there's nothing like being outside and making art.

Artists to investigate:

–Theodore Rousseau

–Claude Monet

–Camille Pissarro

–Auguste Renoir

–Alfred Sisley

French easel set up on site with painting in progress

Oil painting of a wooded path in the Arroyo Seco, California

If you opt to walk to a location, travel light and consider purchasing a backpack designed specifically for plein air painting. Bring extra supports and media if you're driving to a location and painting near your vehicle. You might want to change things up! —A. R.

Here's what you'll need:
- Easel (French easel or pochade box)
- Palette
- Paints
- Rag or paper towels
- Wet box for transporting wet paintings
- Sketchbook
- Pencils
- Erasers
- Water jar with lid to transport brush cleaning water, canvases or panels (it's best to have too many than not enough)
- Camera (optional)

Recommended personal items:
- Lightweight collapsible stool
- Sunscreen and/or hat
- Clamp umbrella
- Water
- Insect repellent (if needed)

#150 Art Apps

Why wait in line at the post office with only your thoughts to entertain you when you could be playing with one of the many great art applications downloadable to smart phones and tablet PCs! There are applications that introduce you to and quiz you on art historical images. Others let you digitally paint or draw and manipulate photos. Many museums and galleries make their collections accessible via their own apps. The app world is ever-changing, so hunt for art-related applications in your favorite search engine, and narrow down your results by adding "sketch," "draw," and "paint" to your search. —A. R.

MENTAL EXERCISES

#151 Drink it Up!

Choose a brand of beverage that best fits your persona. Are you a colorful martini, a super-healthy green drink, or a stout pale ale? Hey, maybe you're chocolate milk! Think about your choice and explore the ways your choice of beverage reflects your approach to creative endeavors. And while you're at it, pour yourself the drink of your choice! —L. K.

#152 Painting with the Sole

Step 1 While sitting or lying on your back, bend your knees so your feet are flat on the floor.

Step 2 Slide one foot forward and backward several times, keeping your sole flat on the floor. Rest a moment, as you notice the difference between the working and non-working sides of your body.

Step 3 Next, keep the same foot flat, and slide it from side to side. Pause. Then start to connect the dots and make a circle, moving your foot in one direction before stopping and doing the same motion in reverse.

Step 4 Break for a moment before continuing with the same foot, imagining there is paint on the sole. Try to create different shapes while moving at varying speeds.

Step 5 Rest again, and play close attention to the sensation in your legs and hips. You may even notice changes in your back, shoulders, neck, and head.

Step 6 Repeat the same movements on the opposite side of your body and then rest.

Step 7 Finally, begin to move both feet in circles, first going in the same direction and then in opposite directions. Create other shapes, draw the alphabet, or write your name. One foot draws it forward and the other backward. Notice if your imaginary paint changes color. —L. K., inspired by Guild Certified Feldenkrais[CM] Practitioner Darcia Dexter

#153 **Transparencies**

There are many different media to explore when experimenting with art, but what about experimenting with unconventional surfaces? Collect a group of varied surfaces that are transparent or translucent. Such traditional art supplies as tracing paper, Dura-Lar®, and velum are perfect, but don't stop there! Get yourself some tissue paper, paper towel, toilet paper, and even toilet seat covers. Using ink wash and pen and ink, create either representational images or abstract shapes and lines on various materials. When you've gathered a collection of shapes, try collaging them onto a piece of Bristol board. Layer shapes to create a sense of depth.

—A. R.

For this example, I painted several trees in ink on sheets of Dura-Lar and drew crows in pen and ink. Each additional layer pushes the first layer back farther in space.

#154 **Evoke Creativity**

Best-selling personal growth author and teacher Shakti Gawain recommends invocations to summon creative energy and achieve focus. Start by easing into a relaxed state. Then say aloud: "I call forth the quality of creativity," followed by "I call forth the master energy of Leonardo da Vinci" (or any other great artist you find inspiring that day). Finally, allow yourself to feel their creative genius flowing through you! —L. K.

#155 Opposing Forces

Create a work of art juxtaposing archetypical opposing forces like male and female, hot and cold, rich and poor, night and day. The possibilities are endless. This can be a painting, pen and ink drawing, sculpture, or any media you like. Try to think abstractly instead of in a straightforward manner. For instance, if you choose night and day, don't simply go with a sun and a moon. Make a list of the types of animals and plants that are only active or blooming at night versus the day. How have various cultures responded to or celebrated each? Write down emotional words associated with each element. Research other literary, musical, or visual artworks that have explored either theme. The mutual attraction and tension between opposites is an excellent resource for content. —A. R.

#156 Sweep Away the Cobwebs

If you're working at home and find yourself stuck in the middle of a project, stop and get out your broom! Doing something that requires repetitive movements helps get your mind into a different rhythm. It's easier to "see" a solution or creative approach when you change your pace and distance yourself from the problem. Treading slowly through it only leads to wallowing in indecision and doubt. As you brush away debris on the floor, concentrate very hard on the problem and then let it go. Sweep out the cobwebs in your brain! Some really brilliant answers will naturally appear. —L. K.

#157 Tactile

Why should artwork be solely for the eyes? Some artists create work that isn't only visually engaging, but beckons the viewer to touch it. Your assignment is to create a work of art using any tactile materials you can find. It can be two-dimensional, meant to hang on a wall in a frame, or it can be three-dimensional, meant to be viewed in the round. Don't sacrifice aesthetic beauty for tactile stimulation; make the piece work on both levels. Explore various fabrics, sequins, beads, and natural materials like bark, gravel, and sand. Create textures with clay or by distressing wood. How does one texture transition from the next and why? —A. R.

Gretchen Jankowski, *Living With Cotton Candy*, Mixed Media Installation, 2009

Gretchen Jankowski, *Living With Cotton Candy* (Detail), Mixed Media Installation, 2009

#158 Cook!

Think of a food item you see in your supermarket that's befuddled you for ages. Buy it and figure out how to cook it. Do some research first: find out what it is, in what type of cuisine it's used, and how. Be ambitious and try many recipes. You can make a game of this; dare yourself to try and use a new type of food each week. Investigating your nearest ethnic grocery store is a great way to find new and interesting ingredients. This type of outside-the-box experimentation gets the creative juices flowing. —A. R.

#159 Loosen Up!

One thing gifted artists taught non-profit executive Cheryl Posner is that doodling is a great way to loosen the structures of the mind and create space for the imagination. Try this exercise to free up some gray matter. —L. K.

Step 1 Begin with a sheet of plain paper and a colorful drawing instrument of choice. Whether it's a crayon, felt-tip marker, or colored pencil, select the one color that catches your attention first.

Step 2 Start drawing, letting the force and energy of the color guide your hand. When that color no longer speaks to you, reach for the next color that demands your attention. It doesn't have to complement the first color.

Step 3 Allow the second color to draw for you. When you and the colors have said what you needed to say, ponder your doodle, put it carefully aside for later review, and go on with your day.

#160 Negative to Positive

Remember not to overlook the negative space when looking at a scene. Most artwork, be it in two dimensions or three, includes both positive and negative space. The abstract shapes that result from being in the "background" can be just as interesting as the positive space. In this assignment, set up a still life with variously shaped objects that have a lot of negative space. —A. R.

Step 2 Now take those negative shapes and the flattened positive shapes, and layer them to create an abstract composition. Don't be afraid to reuse certain shapes to create a pattern, as illustrated in the second example (above).

Step 1 Begin by drawing only the negative spaces in between and around the positive shapes.

▼ **Step 3** In this last step, choose a basic color harmony, like mono-chromatic, analogous, complimentary, or triadic, and paint in the shapes that you've drawn.

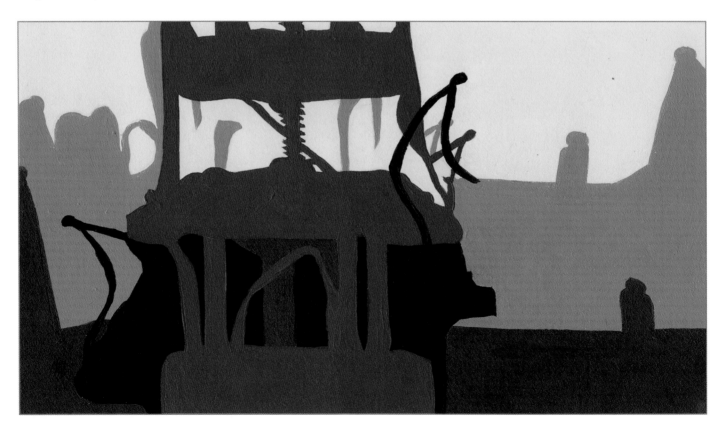

#161 Go the Other Way

The next time a project frustrates you to the point that you're completely over it, take a few minutes to do the opposite of what you were doing. For example, if you've spent hours on the computer, take a break from typing, and doodle with colored pencils instead. If you're drowning in color chips following a color consultation, go to a blackboard and, using white chalk, jot down descriptive words about either the client's personality or the desired effect for the space. You'll soon notice your intuition surfacing, as well as the courage to go with your instincts. Writing words on a blank canvas engages your creative side of the brain, only in a different way. —L. K.

ASSIGNMENTS

#162 That's Punny

If jokes weren't replete with imagery, they wouldn't be funny. Take a simple joke you like and illustrate it. Why did that chicken cross the road anyway? Don't just draw a picture. Think of how creatively you can play with visual puns. Political cartoons are an excellent example. Try at least five different jokes. Start with only sketches and move into any media you like thereafter. —A. R.

#163 Mary Beth Volpini

Photo © Eugene Hedlund of dMedia

Biography: Mary Beth has loved all forms of creative expression since her childhood. She spent twenty-five years as an interior designer upon graduating from Parsons the New School for Design in New York City. She is certified in both New York and California. She rediscovered painting and mixed media collage while fighting breast cancer in 2006 and has since become a Certified Art for Healing Facilitator in the Zagon Method. She now combines her love for color, collage, painting, and mixed media, and enjoys helping others unleash their artistic abilities!

Q: Where do you find inspiration for your artwork?

A: I love to observe the world around me. There is so much beauty in nature. I also love quotes and enjoy creating a visual to depict what the quote means to me.

Q: What do you do when you get artist's block?

A: I really haven't had artist's block in a long time. I have so many ideas and not enough time to create them all.

Q: How do you challenge yourself in the studio and avoid repetition?

A: I am not so sure repetition is such a bad thing. It's hard for me to create the exact same thing twice. Pieces can have a similar look, but I'm at a different place in life for each piece, so I think that comes across. I find taking a class by other artists also helps. They can expose you to other materials and techniques you can incorporate into your own work.

Q: What advice would you give to a blocked artist?

A: Try not to think about being blocked. Look at magazines, blogs, web sites, and nature for inspiration. Play with different materials. Do not try to create a finished piece; just play with the medium.

Flower Garden

Artworks © Mary Beth Volpini

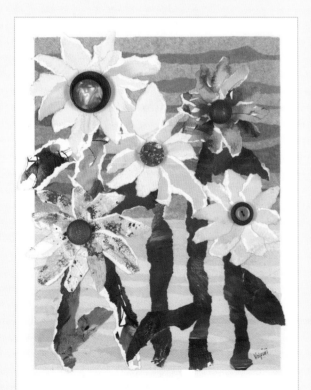

Simple Pleasures

Q: What artist/s or designer/s do you admire for their creativity?

A: I have always loved Andy Warhol and Peter Max for their use of color. But I appreciate many different artists' work and creativity. I love children's creativity and how deliberate they are with their work. There's no committee in their heads yet.

Q: How do you balance your creative impulses with making work that consumers will buy?

A: I create from the heart and I hope that people are moved by my work. My goal is to have my work licensed, so I may have to become more concerned about appealing to a certain market in the future.

Q: Can you remember a class or an assignment from art school that challenged your creativity and possibly helped to redefine your aesthetic or thinking? If so, what was it?

A: My first year at Parsons School of Design we had to create a metamorphosis in six steps using 6" x 6" x 6" cubes or a 6" sphere to start. I went to the hardware store for inspiration and created my project out of chicken wire and steel wool. I depicted the progression of cancer. The teachers were impressed and I found new confidence in myself. How ironic that twenty-five years later I would be diagnosed with cancer.

—L. K.

#164 **Read**

Allow yourself time to read for pleasure each day. Whether you're reading great works of fiction, nonfiction, or a comic book, your mind is digesting new information or going on a literary adventure, which builds a wealth of content to pull from when blocked for ideas. If you find yourself stumped in the studio, relax and take a reading break. Giving your brain quiet time away from agonizing over ideas provides time for the issues to work themselves out in the back of your mind. —A. R.

ASSIGNMENTS

#165 **Rubbings**

We live in a tactile world that is often taken for granted. Textures abound everywhere, and by capturing them using the rubbing technique, you can add another dimension to artwork. Begin by finding objects with low-grade textures that could easily be used for a rubbing or use immobile textures like tree trunks and concrete. Leaves, baskets, asphalt, gravestones, and tree bark all make for easy rubbings. Gather different lightweight papers like rice paper, tissue paper, and—although it isn't archival—newsprint. Such waxy drawing materials as colored pencils, china markers, and oil pastels work best because they don't smear, but charcoal and graphite also work.

You can create one piece of artwork using multiple rubbings on one sheet in various colors and textures. Alternatively, you can make one rubbing, and then draw or paint on or around it. Use watercolor or ink to make washes, and do rubbings on top after it's dry. Take many rubbing samples, cut them out, and collage them together. The possibilities are endless! —A. R.

Here I used colored pencils and newsprint to create rubbings of various sizes of two different kinds of leaves and a woven round placemat. Upon completion, each was cut out and collaged together on a paper support.

#166 Through a Child's Eyes

My immediate family is spread out around the globe, residing in the United States (Maryland, South Carolina, Pennsylvania, and California) and China. Oftentimes the solitary life of a creative entrepreneur is isolating. When I feel overwhelmed or experience periods of blocked creativity, I pull out art pieces my young nephews created over the years. I marvel at their choice of subject and color, and I feel a sense of pride. I think back to what it was like to create without thoughts of marketplace value or peer acceptance. Viewing their work fills me with joy, lights up my soul, and reminds me to have fun with it all! —L. K.

Artwork © Caleb Krall

Artwork © Caleb Krall

Artwork © John Krall

Artwork © Luke Krall

Artwork © John Krall

Artwork © Luke Krall

104

#167 Visual File Boards

To help create unique "art pieces" for her clients to live in, interior designer Krista Everage keeps a visual board in her studio, and she urges you to do the same. She tacks to the board color combinations and images of any kind that make her feel happy, and she always keeps her sketchbook close at hand. If she spots something inspirational while she's traveling, surfing the Web, or

leafing through books and magazines, Krista always snaps a photo, saves an image to her computer, or gets a sample, and then methodically creates inspiration albums on her computer and keeps files in her briefcase. These files become a continually evolving "big picture" of what spaces should feel like via physical objects. The ideas become reality as she finds, designs, and makes all the pieces that eventually fill the space. —L. K.

#168 Macro

When seen from a distance, individual objects of similar shape, value, and color often appear grouped together as one abstract shape. Look at something from very far away like a city, a group of trees on a hill, or a gathering of people, and draw or paint it as the large abstract shape or shapes that the group of objects appears to be.

In this example, I used a group of marathon runners as a reference. When viewed from a distance, their clothes and heads grouped together, so I quickly painted them in general blocks of color. —A. R.

Acrylic on panel,
8" x 11½"

105

#169 Leftovers

How many times have you procrastinated in starting a painting project because you don't have any canvases? Look around with a creative eye. What else can you paint on? Most artists have matte board corners lying around.

How about embellishing some old clothes or furniture you were going to give away? —L. K.

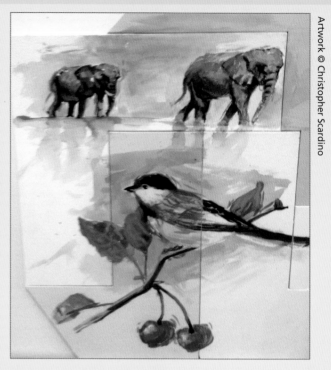

Artwork © Christopher Scardino

#170 Collectibles

Most people have one or two items they're passionate about collecting—from watches to teacups to comic books. Think about the things you collect intentionally, as well as specific items you amass unintentionally. How does it make you feel when you acquire another piece to add to your collection? Pick up a paintbrush or pastel and create an art piece that features the object of your desire. For added fun, wear or display your collectible as you recreate it! —L. K.

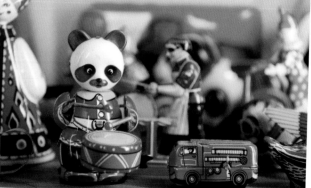

Photo © Linda Krall

Artwork © Karen Cope

A Serious Connection,
15" x 8" x 6",
pigmented plaster

#171 **Never Stop Learning**

Step outside your comfort zone by learning a new medium or technique! If you're a painter, try sculpting. If you sculpt, try printmaking, or anything that challenges you to think differently. You can even seek out fresh ideas about your standard medium. Regardless of your training, there is always something new to learn. Start by looking for local art classes on the Internet. Check community colleges, which typically offer fine arts classes. Or visit art supply stores, which often have an area dedicated to fliers and advertisements for classes and workshops. —A. R.

Sculptor Karen Cope teaches students of all ages and abilities to sculpt the figure from life at Cope Studios in Glendale, California.

#172 **Pungent/Fragrant**

Use your nose as a guide to a visual expression. The sense of smell is one of the most powerful senses for recalling memories. Smell can bring to mind specific imagery related to personal history or to the object that is causing the scent. The mingling of various odors may invoke abstract shapes and color associations. Start with sketches of individual aromas, and see what happens visually when you blend some together. Think in terms of emotions associated with each scent or images from a specific time in your life that the odor reminds you of. Collect a group of disparate smells, both pungent and fragrant, and answer the question: What does that smell *look* like?

Consider the following odors: freshly cut grass, bakeries, a babbling brook, the ocean, red wine, an attic, soil, herbs of all kinds, dead fish, leather seats in a new car, the ignition of a match, roses, cigars, campfires, old sports equipment, babies, Grandma and Grandpa's house, a pine forest, asphalt after a rain, chlorine. —A. R.

#173 **Rescale It!**

Working on an unfamiliar scale forces you to break your formula and think differently about concepts, techniques, and formal devices. Shift the scale of your artwork dramatically. If you make large paintings, drawings, or sculptures, create something that beckons close inspection. If you're used to making small artworks, trade in your detail tools for the industrial size, and catch eyes from far away. Take a photo of the piece that you are working on and assess it as a thumbnail image on your computer. Print out a copy of your small artwork at five times the size of the original and see how it changes the perception of it.

Kevin Stewart-Magee creates paintings on all scales, from the standard sizes we all know and love, to Herculean sizes that can cover exterior walls of multistoried buildings. I asked Kevin how creating artwork on such a large scale effects his creativity. "When I paint some small thing at a huge size, it makes you look very closely and learn a great deal about what you are painting," he said. "Also the terror of a blank canvas is never quite the same after you paint a mural…it changes the definition of impossible in strange ways. *Impossible* is just something that takes more time than you have right now, more stuff than you have on hand, or more skill than you think you have. But overcoming that thought got us to the moon, and makes murals happen every day. Find the time, get the stuff, and learn what you need to know to reach the intention or goal." Well said! —A. R.

Kevin in the beginning stages of painting the large-scale mural in his studio

Fragile Moments, detail

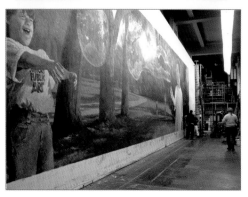

Finished mural in studio being prepared for transportation and installation

▼ Final installation at Walmart, Huntington Beach, California, 2001

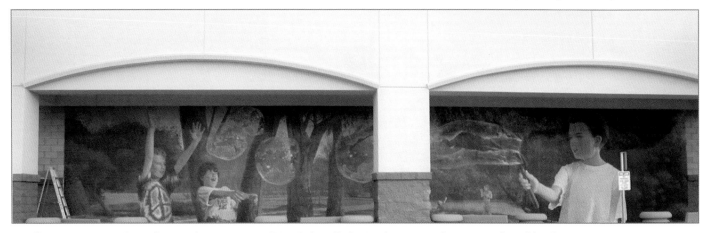

Fragile Moments, mural, acrylic on polyester canvas, 65' x15', installed at Walmart, Huntington Beach, California, 2001
Clients: the City of Huntington Beach and Walmart. Concept/design and painting: Kevin Stewart-Magee. Painting: Christine Wiseman

#174 Do it Now!

Think about all the "you can't do that" rules that apply to painting and create a work that proves they're wrong! —L. K.

#175 Food Fun

Early artists and painters relied on colors and pigments derived from nature. Dyes consisted of berries, plants, and ground ocher from the earth. Linseed oil and other ingredients helped bind the colors to create a decent consistency for paint. An artist friend told me that when she was in college, she met a semi-famous painter who insisted on using ground up ochre as the old masters did and used his students as day laborers. When she was hired to create a watercolor mural along an archway overlooking a client's private vineyard, instead of going to her usual paints, she ventured out into the vineyard, crushed some grapes, and used the glorious liquid as the pigment for painting the grapes in the mural. Another artist friend accidentally spilled coffee on his sketchbook, and the simple act of watching it bubble to the surface inspired him to paint with it! What food items, both typical and unusual, do you think would be fun to experiment with? Ketchup, mustard, soda? Try it…allow yourself to play! —L. K.

#176 **Bilingual**

Despite traditional artwork's status as being perpetually mute, people often speak about it linguistically. A unique, formal style is sometimes referred to as the visual language of the artist. So, what would it look like if a piece were bilingual? How would the visual language of Abstract Expressionism look combined with Neoclassicism? Try it out and see what it says to you. After reviewing at least four different art historical movements/eras and styles, choose two very different styles and combine them into one harmonious painting of any subject you choose: landscape, still life, figurative, or non-objective. Don't be limited by palette choices the artists would've used; think more in terms of brushwork or medium. Shift the painting in any direction you want and allow it to take on a life of its own, independent of its stylistic origins. —A. R.

This painting combines the styles of Abstract Expressionism, specifically Jackson Pollock and Impressionism.

Some art movements or eras to consider: Classical/Realism, traditional Chinese painting, Japanese woodblock prints, impressionism, pointillism, fauvism, Der Blaue Rieter, Die Brüke, cubism, abstract expressionism, surrealism, Bauhaus, Andy Warhol-style pop art, photorealism, street art

#177 **Wonky Grids**

The use of a grid is a time-saving and efficient tool to create and enlarge drawings or paintings from reference material. But what happens to an image when that stable grid is distorted?

For this assignment, choose an image of anything you like and draw a grid over it. Make the grid stable and regular. One-inch squares work well (A). On a piece of tracing paper, draw out the perimeter line of your picture plane at the same scale. Draw the same number of lines both vertically and horizontally as your grid, but warp each one. The distortion can take any form, as long as the lines that are headed in the same direction don't overlap. They can be wavy or straight and stretched (B).

Place your final piece of drawing paper over the distorted grid and use a light box or the light from a window to draw your picture according to the corresponding grid squares. Translate the original reference to your warped grid one square at a time. After you've lightly drawn the major forms, you can remove the drawing from the light box or window and refine it more comfortably (C). Now you have a very surrealistic, wonky contour drawing that you can continue to render or use for a painting. —A. R.

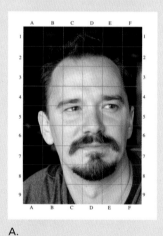
A.

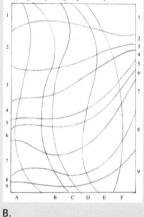
B.

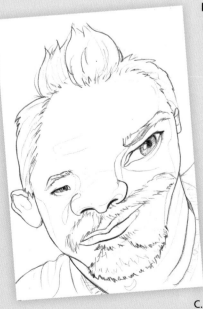
C.

Note: You do not have to use the tracing paper method. It merely saves you from having to erase the distorted grid from the final drawing. You can draw the altered grid directly onto your drawing paper and create the portrait there.

#178 All in the Family

Illustrator and graphic designer Patty Iba and her husband Wayne, an industrial designer, have a passion for "all things creative!" It's no wonder then that when their two sons, Calvin and Cole, began building with LEGO® building bricks, Mom and Dad decided to start building, too! For more than six years, the Ibas have challenged their creativity by participating in the LEGOLAND® Junior Master Model Builder competition. Each month throughout the year, various age groups are given a one-hour time limit and a theme, such as "Into the Future" or "Storybook." If the judges declare you one of the monthly winners, you qualify for the yearly finals held in January. Each person in the Iba household has won numerous times and there are always plenty of family and friends to help cheer them on! Challenge yourself to enter a creative competition. At the very least, set aside some valuable family time to create alongside each other. —L. K.

The Iba-Nunn Family of Fans

Competition is intense with only one hour to build!

Illustrator and graphic designer Patty Iba

Cole Iba, age 8

A proud Iba family with cousin Daniel Fukuchi (far left) displaying their finalist trophies

Calvin Iba, age 10

Industrial designer Wayne Iba

#179 Brain Freeze

When our creativity is blocked, there is usually a specific picture stuck in the brain. Identify the picture you're stuck on. Now close or cover either your right or left eye with its respective hand and see if the picture changes or stays the same. Do the same with the other eye and note any slight differences in the color, texture, or size of the picture. Covering each eye separately reveals how each side of the brain sees an image and gives you a different perspective from what you're used to seeing. To vary the exercise, cover one eye with the opposite hand. —L. K.

#180 History Repeats Itself

The history of art reflects much repetition and the proverbial tip of the hat from one artist to another. Find a painting that reflected popular culture or a sociopolitical issue from an era gone by. Use this painting as inspiration to create a work of art that addresses a contemporary popular culture or sociopolitical issue. Research the painting's context, symbolism, and impact on the audience of its day to gain a deeper understanding of it and how to use it for your chosen subject. The painting should make a clear reference to the source of inspiration and at the same time be altered enough to give it new, contemporary meaning. Avoid simply dropping in different faces over characters in the original. Make bigger connections!

Some political issues to consider: education, the environment, the economy, civil rights, immigration, international relations, etc. —A. R.

Some artworks to refer to:

Gericault, *Raft of the Medusa,* 1818

Jaques Louis David, *Death of Marat,* 1793

Picasso, *Guernica,* 1937

Jean-Honoré Fragonard, *The Swing,* 1767

Ernst Kirchner, *Street Dresden,* 1908

Judy Chicago, *The Dinner Party,* 1974–79

Andy Warhol, *Campbell's Soup Cans,* c. 1960s

Edouard Manet, *Olympia,* 1863

Otto Dix, *Skat Players,* 1920

Pierre-Auguste Renoir, *Luncheon of The Boating Party,* 1881

Artwork © David Fu

This student work visually references the commoner portraits of Édouard Manet, particularly **The Philosopher, Beggar With Oysters,** c. 1864–67. By maintaining some of Manet's formal devices, like a single figure in a limited background with only subtle value transitions and one anchoring still life of trash at the bottom of the picture plane, David creates a link from a past social condition to one of the present. If the viewer is familiar with Manet, we notice something familiar and can easily understand the commentary on this contemporary subject.

Great Depression #2?, acrylic on canvas, 24" x 36", 2011

#181 Make a Statement!

It can be helpful when stuck in the studio to try a different mode of expression, like writing. Professional artists accompany their shows with artist's statements. Write your artist's statement for a show you'd like to produce. Brainstorm first with a list of ideas and words that hit an emotional note for you. Then start to answer some questions:

- What media do you use and why?
- How do you begin to create a piece?
- Why are you creating this work: personal discovery, catharsis, to change hearts and minds, to tell a story, or to simply communicate visually with the audience?
- What do you want viewers to think and feel when they look at your work, if anything specific?
- How long have you been thinking about creating this work, and what experiences in your life have guided you in this artistic direction?
- How do the formal aspects and media choices of the work reinforce your intended message?
- When creating, what emotions are you expressing: joy, anger, frustration, peace, or is it a purely intellectual exercise?
- How do the individual pieces contribute to the dialogue of your larger narrative or concept?
- What and who are your influences?

#182 Do it Now!

Write down everything that comes to mind, stream-of-consciousness style. Boil it down to the essentials, the irreducible ideas that tell the story of your work and your relationship to it. Revisit your statement regularly to update it and gain guidance from it. —A. R.

#183 **Visual Conversation**

A good conversation goes beyond words. Start a visual dialogue with a friend or group of friends. Begin a painting (or drawing) of anything—the interior of the room you're in, your coffee mug, abstract shapes, whatever. Give the artwork to another artist friend to respond to visually. Let your friend alter the artwork in whatever media and manner he or she chooses. Pass the work onto another friend to add to it or retrieve it and come up with a meaningful reply. Let each meeting of artwork to artists be part of a visual conversation, each artist responding to the contribution of the former. Deciding on when the piece is finished is as subjective as deciding when a topic is resolved. This can also be done with a child; the difference in skill and life perspective could create a very interesting "conversation." Occasionally, this dialog becomes an argument. Don't completely destroy the work of another, but add to it, alter it, or enhance it.

Over the course of a few of months, my dear friend and fellow artist Jana Rumberger and I enjoyed a visual discussion via the United States Postal Service. I began the piece with open-ended abstract imagery and sent it to her studio. We never knew what the orientation was supposed to be. Each of us operated under a different understanding of which end was up. The results are shown here: —A. R.

Step 1 I began with random, abstract shapes, dripped and painted onto paper.

Step 2 Jana responded with abstract drawing and painting.

Step 3 I added fingers in the midst of a Balinese dance painted in acrylic.

Step 4 Jana contributed poured acrylic medium and glaze, and changed the value scale of the painting.

◄ **Step 5** I finished the piece with the thought that the fingers were communicating some energy toward each other, so I added light yellow outlines and "sparks."

This is the result of another joint effort between Jana and myself.

#184 Animal Instincts

Budding artists take hours of life drawing classes. How often do you draw animals? At an illustrators' conference I attended in Northern California, a special guest arrived to teach us how to draw horses—one of the most difficult animals to draw, we learned.

As in life drawing, map out how you intend to compose the animal on the page. Begin by making marks and indications where the head will be in relation to the body, and then add more specific details. Will the head be drawn straight on or as a three-quarter profile? Use your instincts to draw body parts and proportions in the same way you would to draw the human form. As you draw, think about the skeletal and muscular structure of the animal, not merely its external attributes. The most exciting part about drawing a live creature is that the original position the animal was in when you started will change as the minutes tick by.

Remain loose and light with the initial pencil or chalk marks and leave all the marks until the very end. Remember how many marks Degas left in his drawings? It gave his sketches movement and life, so try not to worry about yours. As you progress, add more features. Stand back from the drawing, look away from it, and then look back at it with fresh eyes. Fur is a lot like human hair. It's best to create a form or shape first, blocking in darks and then erasing out highlights. As you near completion, it's up to you how many of those initial sketchy lines you are willing to part with. If drawing a large or active animal seems daunting, start with a sleeping cat or an old, docile dog. Then plan a trip to a zoo or a wild animal park, keeping in mind that animals are a lot of fun to draw! —L. K.

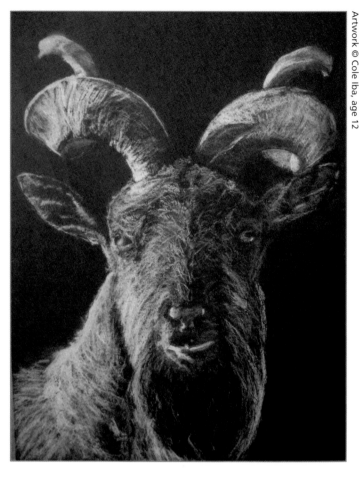

Artwork © Cole Iba, age 12

Markhor in white pastel chalk on black paper

#185 Looking Up

Sit with your eyes open and take note of the position of your eyes at rest. What do you see in front of you? Gently and slowly, as if you're watching a ladybug walk up the wall in front of you, allow the eyes and head to move up and down within a comfortable range. Lower your head and eyes back to the center and pause for a breath or two. Now with the eyes closed, simultaneously raise the head and lower the eyes. Return your head and eyes to neutral for a moment and then repetitively raise and lower the head and eyes together, as if nodding "yes." Notice whether or not it's easier now. Pause again. When you open your eyes, take in whatever is in front of you. Are things looking up? Now go back to your piece and continue… —L. K.

#186 Brain Dump

Typically artists' brains are filled with lots of negative stuff: fear, anxiety, self-doubt, self-loathing, and judgment, as well as plenty of creative, imaginative, and positive concepts. Take a blank piece of paper or canvas and start "dumping" out anything your brain thinks of as fast as it comes to mind. Don't try to put any logic to it…just let it out!
—L. K.

#187 Do it Now!

Look around your home and see where you can add your personal flare by accenting a piece of furniture, an appliance, or another household accessory. Industrial designer Wayne Iba turned these plain kitchen staples into household hot rods. —L. K.

117

#188 Food Face

Don't think of food solely as a source of nutrition—make some art with it! Show someone you care by creating his or her portrait in food. Try arranging various foods to make a face. Paint on food, paint with food, or carve into food and allow part of it to shrivel and die to create a mark. The possibilities are endless!

Consider the types of foods that best describe the person you are portraying. Use fruits and vegetables, processed foods, meats, anything remotely edible. Think outside the box as much as possible and push yourself to come up with at least five different ways to create a food portrait of the same person. Go beyond a portrait and use food to create any type of artwork you like. Then take a picture, because it will most certainly last longer.

Playful and pointed, Jason Mecier's celebrity portrait mosaics not only depict the image of the subject, but also imply a narrative through the use of juxtaposing carefully chosen found objects. From pills to junk, toys to food of all kinds, he constructs his portraits using media he feels best captures his subjects' public personas or plays with visual puns. Although they only last long enough to be photographed, the food portraits are humorous takes on celebrity and tell us as much about public perceptions as they do about the subject. —A. R.

Artists to investigate:
–Giuseppe Arcimboldo
–Sandy Skoglund
–Giorgina Choueiri

Condoleezza Rice, 3" x 4", rice on panel, 2007

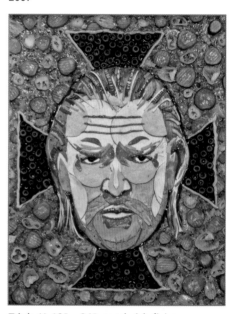

Triple H, 18" x 24", sandwich fixing on platter, 2009

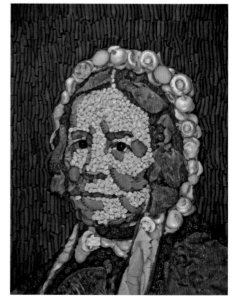

Sarah Hale, 20" x 25", Thanksgiving dinner on platter, 2010

Rosie O'Donnell, 24" x 30", junk food on panel, 2007

#189 A Day in the Life

Set aside one full day, and in a sketchbook depict your activities, the people you interacted with, and the things that caught your interest. A good way to start is by sitting in a café and drawing a little still life sketch to loosen yourself up and access your right brain. Next, observe the postures and gestures of those around you. Limit yourself to no more than fifteen minutes per drawing. You have a full day in front of you, so make it quick. Draw a portrait of your server, challenging yourself to draw facial expressions and fabric. While looking out the window, draw buildings, shadows, signs, shapes and patterns—anything that accurately reflects that pocket of time. Drawing today is not about the details; it's about capturing mood, lighting, shapes, and the spirit of what's in front of you. It's about documenting the small vignettes that ultimately create a one-of-a-kind day. —L. K.

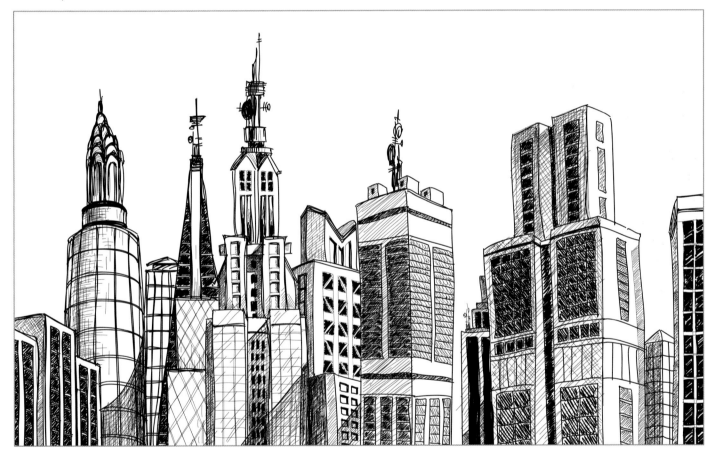

#190 Do it Now!

Go to the computer, find an artist you've never heard of, and see what he or she is all about.

—L. K.

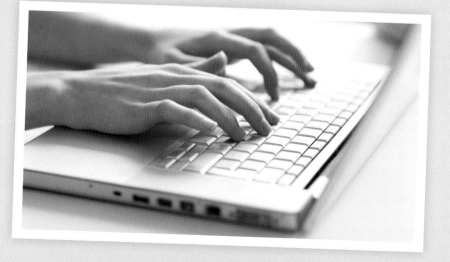

#191 Logo

As Shakespeare wrote, "… brevity is the soul of wit." The same can be said for good logo design. The simplest of forms can speak volumes. Think of creating one emblem that will last you a lifetime, be quickly understood by the viewer, and committed to memory whether printed the size of a thumbnail icon or as large as a billboard. Distill what is fundamentally important about you and the image you want to project to the world down to a basic visual statement and design a unique logo for yourself.

When designing a logo, everything counts. Use the positive and negative space wisely. Combine and morph forms to get double meanings out of the same shapes. Will you reference something representational like an animal or use basic abstract shapes whose character implies your essence? Will the design elements project strength and stability, or should they be dainty and floral? Will you use heavy, jagged lines, or curvilinear, light lines? Perhaps there will be four bold, pure hues, or simply one muted color. Create a flexible logo that will remain relevant for years to come. Although it will be fun, it may not prove to be an easy task if you really consider all of your options. —A. R.

#192 Fantastical Future

Where and how will human beings inhabit the future? Draw the most fantastical, futuristic building or street scene you can imagine. Create it from a dramatic angle in one-point perspective or in two-point perspective as though you're looking at it from a street corner. What kinds of building materials might be used in the future? Could buildings be made of ice? Will they float? What if a building were to grow from the ground like a plant? What if your fantastical group of humans no longer lived on earth? Push your concept beyond brick and mortar, and think! —A. R.

#193 Art History

Brush up on your art history! Learning about art history is more than a perfunctory exercise in which all art students must partake. It's a fascinating visual chronology of the history of human aesthetics, actions, thoughts, emotions, and philosophies. To study art history is to study literature, world history, politics, world cultures, sociology, and anthropology. By becoming a keen observer of the arts, you'll become a keen observer in life. Read artists' biographies, manifestos, and academic books on particular movements and eras. Take a class on art history at a community college. Watch documentaries and films about artists' lives. Go to art museums and take guided tours. Consume the history of the art of the world however and whenever you can. You will better understand that which has come before, what is relevant now, and how you may or may not fit into it all. —A. R.

Laocoön and His Sons, Roman white marble copy of original Greek bronze, ca. first century B.C., the Vatican Museum, Rome

121

#194 Welcome to Now

It's time to become a participant in the twenty-first century! If you aren't familiar with new digital art and design programs, take a class or buy a manual and get acquainted. These programs are like learning about any new art media. You can use them to create finished pieces of artwork through digital drawing, painting, sculpting, and photographic manipulation. The effects can be deceptively realistic, fooling even the trained eye into believing that it is looking at an image created with such traditional media as charcoal, watercolors, oils, pens, or markers. Conversely, digital art programs can create spaces and textures that are simply not possible through traditional means. They also provide time-saving shortcuts in designing pieces that will eventually be executed by hand. Old dogs can learn new tricks, so get clicking! —A. R.

A few programs to explore:

Adobe® Photoshop®

Adobe® Illustrator®

Adobe® After Effects®

Corel® Painter™

Autodesk® SketchBook® Pro

MyPaint

Autodesk® Maya®

Autodesk® Mudbox™

3D-Coat

Pixologic™ ZBrush

Pixologic™ Sculptris

Tawd, Jessica Salehi, Graphite and Adobe Photoshop, 2010

Artworks © Jessica Salehi

Circus Survival, Jessica Salehi, Adobe Photoshop, 2011

#195 I Capture Candyland

Perhaps you've conquered that sugar addiction, but when you think back to childhood, can you remember how exciting it was to get a special sugary treat? Pretend you're locked in a sweet shop where there are shelves and buckets of every kind of candy you can imagine, and an ice cream parlor to boot! Paint or draw what you see and feel. —L. K.

#196 Word to the Wise

Let's not forget about the local library as a source of inspiration! Every library should have a section of books about art and artists. It's amazing what you stumble upon when you browse leisurely. Make sure to take a sketchbook to jot down notes and sketches for later reference. —A. R.

#197 **Stop Saying No!**

Animator Chuck Jones was, and continues to be, an inspiration to many—especially his grandson, Craig Kausen, Chairman of the Board of Trustees for the Chuck Jones Center for Creativity. A favorite piece of his grandfather's art conveys a message that has always resonated with Kausen: "Stop saying NO. Stop listening to NO. When you stop saying and listening to NO, your creativity naturally bubbles back to the surface. Most importantly, listen to the voice inside that continues to tell you NO before you even begin. Hear it. Acknowledge it. And move past it. Your inspiration is there." —L.K.

#198 **Visual Puns**

Visual puns play with images in the same way that puns play on words. Some compound words and phrases imply more than one meaning at a time. Imagine you're new to the English language. What would the phrase "pigeon-toed" look like to you the first time you heard it? Probably not like a person with inward-pointing toes! Bust out your sketchbook and have some fun exploring double meanings through drawing. —A.R.

Give some of these possible puns a spin and find some more of your own:

Brainwash	Lemonade	Birdbrain	Tow truck	Friendship
Fire drill	Butterscotch	Bonehead	Eye candy	Daybreak
Fruit flies	Shortbread	Crowbar	Cat burglar	Rainbow
Serial killer	Bulldozer	Pigeon-toed	Honeymoon	Tapeworm
Corndog	Light-headed	Firearm	Bellbottom	Chocolate mousse
Rubber band	Water gun	Fountain pen	Air guitar	Horsefly

Backdoor, pen and ink, 2011

Jellyfish; pen, ink, and digital, 2011

Mobile Homes, pen and ink, 2011

Artworks © Gedimin Bulat

124

#199 Tessellation

Tessellations are tightly fitting, interlocking, repetitive patterns that have no gaps or overlapping, such as a simple puzzle or a honeycomb. Artisans have used them for centuries, particularly in decorative tile patterns for mosques and cathedrals. Challenge your brain and your creativity by creating one for yourself. Start your first tessellation by creating a "tile" with a simple geometric shape like a square, triangle, or hexagon. It's important that all of the tiles be exactly the same shape to avoid gaps and overlaps. When the tile is figured out, try sliding it around with other tiles like it to see how it can fit together. Flip the tiles over and try to interlock them from above and below. Rotate the tile on one pivot point and create a radial tessellation. Then try something more complicated like a representational object, animal, or person. How can you bend and distort that shape so it fits together like tiles with another identical shape? There are a lot of web sites dedicated to tessellations and guides on creating them for yourself. Definitely consult one if you get stuck. This isn't only a creativity exercise, but a mental challenge on your spatial relationships. —A. R.

Artist to investigate:
—M.C. Escher

#200 **Did You Know?**

Recent studies reveal that so-called artistic genius may not necessarily be a product of innate talent, but rather good, old-fashioned hard work and praise. According to researchers at Exeter University in the United Kingdom, opportunities, training, motivation, encouragement, and practice are the five ingredients necessary to ensure excellence.

#201 **Dare to Be Different**

Ralph Waldo Emerson wrote: "The two terrors that discourage creativity and creative living are fear of public opinion and undue reverence for one's own consistency."

As you close the book on combating creative block, think regularly about new ways to make peace with criticism and climb out of your comfort zone. Write them down, sketch them out, or say them to yourself in the mirror every morning. Just never stop doing.

Contributing Artists and Experts

Juliette Becker..www.juliettesfineart.blogspot.com

Shelly Becker-Cornelius ...www.moxie-creative.com

Gedimin A. Bulat ...www.gedimin.com

Karen Cope...www.copestudios.com

Domenic Cretara ..www.cretaraart.com

Darcia Dexter ..www.darciadexter.com

Krista Everage...www.everagedesign.com

David Fairrington ..www.DavidFairrington.com

Sandie Glass ...www.sandstormideas.com

Shakiba Hashemi ..www.shakibafineart.com

Nathan Huff ...www.nathanhuff.com

Patty Iba..www.bluefire-creative.com

Craig Kausen ...www.ChuckJonesCenter.org

Pam Marsden ..www.ChuckJonesCenter.org

Tommy Martinez ..www.tommymartinez.com

Janine McDonald...www.j9leadingsolutions.com

Siobhan McClure ...smcclurerose@roadrunner.com

Jason Mecier...www.jasonmecier.com

Robert Merchant..rem.designer@gmail.com

Ya'el Pedroza..www.ypedroza.com

Lala Ragimov..www.lalaragimov.com

Carrie Reynolds ...www.gotoreynoldsdesigngroup.com

Nathan Rohlander ...www.rohlander.com

Jana Rumberger ...jana.rumberger@gmail.com

Christopher Scardino ...www.scardinoart.com

Jessica Salehi..www.jessicasalehi.com

Alice Simpson ...www.alicesimpson.com

Anne-Elizabeth Sobieski..www.aesobieski.com

Kevin Stewart-Magee...www.kevinstewartmagee.com

Mia Tavonnatti..www.miatavonnatti.com

Brian Thompson...http://bthompsonart.blogspot.com

Mary Beth Volpini........... mb@drawntocolor.com; www.drawntocolor.com; www.marybethvolpini (blog)

Thank you to everyone who helped make this book possible:
Shelly Becker-Cornelius, Michael Haynes, Erika Kotite, Pamela Marsden & The Chuck Jones Center for Creativity, Carolyn Miller, David Rohlander, Nathan Rohlander, and Jana Rumberger.

Linda Krall

Linda Krall is a creativity consultant and author of *The Wild Idea Club,* a "Best in Business" finalist at the San Diego Book Awards. Linda engages and inspires audiences with stories of her experiences working around the globe as a strategic illustrator on PepsiCo, Duracell, General Mills, ConAgra Foods, and GlaxoSmithKline brands, and many more. She holds a BS in Education with an emphasis in Arts, Communication, and Psychology from The Pennsylvania State University. In her downtime, Linda can be found hanging with the Harley-Davidson® motorcycle crowd or cheering on her favorite sports team, the Pittsburgh Steelers.

For more information about Linda, visit www.lindakrall.com

Amy Runyen

Amy Runyen is a fine artist, illustrator, author, and an adjunct professor/lecturer of art. She earned her MFA in Drawing and Painting from California State University, Long Beach, and her BFA in Illustration from Savanna College of Art and Design, Magna Cum Laude. She has shown her fine artwork in galleries nationally and internationally. She has authored and illustrated nine how-to-paint books, and has written about art history in *The Daily Book of Art* (Walter Foster Publishing). She lives and works in South Pasadena, California, with her husband, artist Nathan Rohlander and their son.

For more information about Amy, visit: www.amyrunyen.com